Sherlock Jones
and the
Assassination Plot

SHERLOCK AND PENNY ARE field testing a new pair of high-tech walkie-talkies when their units pick up a startling conversation. Someone is planning to assassinate Governor Bradford! The only clue that the young detective can glean from the brief radio transmission is the mention of the word "Sidewinder."

THE two young people go to the local police to report the assassination plot but find that the Chief won't listen to them. Determined to protect the governor, Sherlock comes up with a most unusual plan to stop the assassins.

PACE Publicati

Independence MO 64

ISBN 0-91847-

W9-CQG-033

SHERLOCK JONES

JONES

AND THE ASSASSINATION PLOT

By ED DUNLOP

Sherlock Jones and the Assassination Plot
By Ed Dunlop

Cover illustration by Scott Freeman
Copy Editor: Julia C. Hansen
Proofreaders: Sheri Harshaw and Kenda Childers

Published by PACE PUBLICATIONS
Independence, MO 64055

Printed in the United States of America
Set in Times New Roman 12 point
ISBN 0-91847-11-7

Dedicated to Hazel Boggs,
my favorite camp cook

*"In the beginning
God created the heaven and the earth."
Genesis 1:1*

OTHER BOOKS BY ED DUNLOP

The Young Refugees

Escape to Liechtenstein
The Search for the Silver Eagle
The Incredible Rescues

Sherlock Jones, Junior Detective

Sherlock Jones and the Willoughby Bank Robbery
Sherlock Jones and the Assassination Plot
Sherlock Jones and the Missing Diamond

Table of Contents

1 – A Strange Message

The huge, golden butterfly rested like a rare jewel in a cluster of leaves. Its big, bright wings were spread wide in a colorful display. I crept along the mimosa branch below, clinging to the tree branch overhead with my right hand with butterfly net poised in my left hand. I hardly dared to breathe lest the beautiful creature should decide to take wing before I was in position for the capture.

Leaning forward cautiously, I slowly extended the net as far as I dared. What a magnificent specimen! I had never seen anything like it. I brought the net down gently. Just two more inches and the butterfly would be mine. Jasper would be pleased.

Crack! The branch broke suddenly, and I found myself falling. I struck the rocky embankment below, then tumbled head over heels over butterfly net in a painful, knee-wrenching, elbow-scraping slide all the way down the steep, shale-covered slope. A tree trunk at the bottom of the incline abruptly stopped my wild tumble. I hit with such force that the breath was knocked out of me, and in the midst of my pain I heard a loud grunt.

I struggled to my knees, trying desperately, painfully, to draw air into my empty lungs. But my

diaphragm refused to cooperate. For several long, agonizing seconds, I heard a strange screeching sound in the back of my throat, but I still couldn't inhale. I needed air—my lungs were screaming for it—but I couldn't even draw a breath.

After several moments of agony, my diaphragm relaxed, and I gratefully drew breath after breath in ragged little gasping sobs. Tearfully, I struggled to my feet.

My elbows were stinging, my knees were bloody, and one sleeve was nearly torn off my favorite plaid blouse. My bright yellow culottes were dusty and splotched with blood. I picked up the mangled butterfly net. The red fiber glass handle had snapped in two, and the mesh netting was nearly torn from the wire hoop. The net was destroyed, my clothes were ruined, and I was hurting all over.

I stared in dismay at the ruined net. It was brand new, and it wasn't even mine. Jasper would be upset.

Jasper Jones! This was his fault! Suddenly, I was furious. This whole butterfly-catching catastrophe was all his idea, and he hadn't even showed up at two o'clock like we had agreed. I glanced again at my bloody knees. When Jasper did show up, boy, was he gonna catch it! We Gordons have never been known for possessing forgiving spirits.

"Penny!" The voice startled me, causing me to drop the ruined net. "Penny! What happened?" Jasper's face suddenly appeared at the top of the incline, right beside the offending mimosa tree.

"What do you think happened?" I snapped. "I've been attacked by sharks!" The stinging pain in my elbows suddenly intensified, and I bit my lip to keep from crying in front of him. I was embarrassed, hurt, and angry all at the same time.

The loose shale on the incline tumbled and clattered as the skinny figure in the faded blue jeans slid down toward me. When he reached my side, I let him have it with both barrels. "This is all your fault!" I raged. "Catching these stupid butterflies was your idea. And you weren't even here at two o'clock, like you promised!" I bent over and picked up the butterfly net, thrusting it at him as if it were the source of all my troubles. "Here! Take this stupid thing! It's ruined now, anyway!"

He took the net without even glancing at it. Looking up at me with a worried expression on his thin face, he asked softly, "Are you OK, Penny?"

"No!" I exploded, "I'm not OK! I'm skinned and bleeding, and my clothes are ruined! And I broke your stupid butterfly net!"

The anxious look in his brown eyes bothered me. If he had made fun of me like other boys would have, or if he had lashed out at me, I could have taken it. But he just stood there meekly, his kind face reflecting his concern. My anger evaporated

3

immediately. "I'm sorry," I stammered, feeling embarrassed at having lost my temper. "It's not your fault."

"That's all right," he reassured me gently. "And don't worry about the net. I still have another one." He glanced up the hill, then turned back to me with a puzzled expression. "What did happen, anyway?"

I started up the incline, slipping and sliding in the loose shale, and Jasper followed. "There was a really awesome butterfly up in this mimosa," I explained. "Jasper, it was huge! It was a fantastic golden color, and it must have had a wingspan of six or seven inches! It was resting on the end of that branch up there, and it had its wings spread wide open, and . . ."

I gave a sudden little cry of delight. "Look, Jasper!" I pointed. "It's still there! I can't believe it! It didn't fly away!" I guess I danced a little jig right there in my excitement, then pointed the butterfly out to him.

Jasper retrieved his butterfly net from the top of the slope, then climbed the tree. I held my breath as he inched slowly toward the insect. "Careful!" I called softly. "One of the branches broke under me, you know."

"I don't weigh as much as you, though," he answered, and I stuck my tongue out at him. But it was true. I'm tall and skinny, and I suppose I weigh about as much as the average sixth-grader. But

Jasper, on the other hand, hardly weighs more than a mosquito.

He neared the end of the branch and extended the net toward the butterfly. Then, for some reason, he retreated back down from the tree without the insect. He was snickering as he climbed down beside me.

"Why didn't you catch it?" I asked in bewilderment. "It's still up there. I can see it!"

Jasper removed his thick glasses and handed them to me. "Here, Penny," he said with a grin, "I think you need these more than I!"

I stared at him, getting the uneasy feeling that I was about to be humiliated again. "What are you talking about?"

He had given up trying to be polite, and was now doubled over with laughter. "That wasn't a butterfly, Penny!" he hooted. "It was just two big, yellow leaves!"

I snorted my disgust. "You mean I risked my neck to try to catch two leaves? I almost got killed!"

He was still laughing. "A butterfly at rest doesn't usually spread its wings like that," he told me. "A moth does, but a butterfly rests with his wings held together vertically."

I shrugged. "How was I to know?"

Jasper picked up my damaged net, bent the wire hoop back into somewhat of a circle, then opened the collecting kit slung over his shoulder and removed three or four rubber bands. In seconds,

he had secured the torn mesh back to the hoop. When he finished, he surveyed the completed product, then shrugged. "Not very fancy," he observed, "but it will still catch butterflies." He handed me the undamaged net, retaining for himself the one that I had messed up.

Then I noticed the pair of walkie-talkies hanging from his belt. They looked just like the ones the police department uses, and they were gigantic—not like the plastic toy ones they sell to kids that have a range of about twenty feet. "Awesome!" I said. "Where did you get those?"

He handed me one of the walkie-talkies, and the grin on his face told me that this was a prized possession. "I just got them this week," he told me. "I've been saving for them for two years. They're the best."

He took the second walkie-talkie from his belt, clicked a switch, and the radio in my hand began to beep softly. "What's it doing?" I asked.

He grinned. "That's the signal to turn your radio on," he explained. "Even if you have your power turned off, I can signal you to turn yours on so we can talk."

I was impressed. "How far will these things reach?" I asked.

"You get a good, strong signal for at least six miles," he told me, "Eight if the conditions are right. You and I only live a quarter of a mile apart,

so we can call each other's house with no trouble at all."

He turned and started up the incline. "Stay here," he said. "I want to try them out. When I get to the top of the hill, I'll signal, and you turn your unit on."

He disappeared into the woods, and I sat down on a stump to wait for his signal. Beep—beep. Beep—beep. I turned the radio on, and Jasper's voice came out of the little speaker crystal clear, almost as if he was standing right beside me. "Calling Penny Gordon," the voice said. "Penny, do you read me? Over."

I held the walkie-talkie up to my mouth. "I read you, Jasper," I replied. "Do you read me? Over."

"Calling Penny Gordon," the voice repeated. "Come in, Penny. Over."

"I'm answering, Jasper," I said into the speaker. "Can you read me?"

"Calling Penny Gordon," Jasper said again. "Penny, push the black button on the side of the unit to talk to me. Over."

I looked at the walkie-talkie, and sure enough, there was a long, black plastic bar on the side of the case. I squeezed it, then held the walkie-talkie to my mouth again. "Gotcha, Jasper," I said into the speaker. "Do you read me now? Over."

"Loud and clear, Penny," his voice replied. "I'm about five hundred yards up the slope, and the

reception is just fine. I'm coming back down to you. Over and out."

I squeezed the talk button. "See you in a minute. Over and out."

Just then, a voice came out of my walkie-talkie, but it wasn't Jasper's. "I don't like it," a man's voice said. "We're taking an awful risk. What if the cops are on to us?"

I stared at the walkie-talkie in my hand. Who was that? And then, another voice cut in. "Don't be an idiot! The cops don't even know we're in the state. I've taken precautions to make sure our tracks are covered. And the contract is paying a hundred thousand."

The second speaker was a woman, but her voice was cold, sinister, and threatening. The tone of her voice gave me a very unpleasant feeling, like the screech of fingernails on a chalkboard. Had I known that Jasper and I were to meet the owner of that voice in just a few days, I probably would have been terrified.

The man's voice came on again. "Yeah, but wasting the governor? I tell ya, I don't like it. A hundred grand or no, we'll be running an awful risk. There'll be bodyguards, and cops, and—"

"Quit whining!" the sinister-voiced woman interrupted. "You're getting paid well. I'm the one taking all the risks."

Goose bumps ran up and down my spine. If these people were talking about what I thought they

were talking about, this was serious stuff! A sudden noise on the hillside above startled me, and I looked up to see Jasper emerge from the trees. I pointed at the radio in my hand and he nodded silently. Then I knew that he had heard it, too.

"Gotta run," the man's voice cut in. "The Sidewinder is here. Talk to you later." There was a click, then what sounded like a dial tone on a phone. And then, the radio was quiet.

Jasper had reached my side. I stared at him, wide-eyed. "Were you listening to that, too?" I asked, in a feeble, shaky voice.

He nodded grimly. "Sounds like someone's planning to assassinate Governor Bradley," he answered. "Penny, we've got to get to the police!"

As I switched off my walkie-talkie, I wondered who "the Sidewinder" was. I knew that a sidewinder was a rattlesnake, and for that reason, this guy sounded dangerous.

2 – The Police Station

I stared at Jasper, stunned by the ominous message we had just heard on the walkie-talkies. "Why would anyone want to kill Governor Bradley?" I asked. "He's the best governor we've ever had, and he's a Christian!"

Jasper nodded. "But just because he's a Christian doesn't mean that everyone is going to like him," he observed. "In fact, in today's world it's easier to make enemies if you are a Christian."

He switched off his radio, then hung it on his belt. "Look at what the governor stands for," he said. "He's pushed for stronger legislation restricting abortions, he's opposed the institution of a state lottery, and he's trying to impose restrictions on the sale of alcohol."

"But he stands for what's right!" I objected.

"I know. But he's made a lot of enemies. In just one term, Governor Bradley has cleaned up a lot of corruption in the state government, and he has a lot of people worried. And now, apparently someone is out to get him."

We hiked up out of the river bottom. Before long I was huffing and puffing, walking as fast as I could to try to keep up with Jasper. He's a year

younger and about five inches shorter, but he walks faster than I do.

Jasper and I are both in sixth grade at Willoughby Elementary School. He skipped third grade, so he's the youngest—and the shortest—kid in our class. He's a real brain. My desk is next to his in homeroom, and we're becoming friends. He's all right, for a boy.

Jasper wants to be an entomologist when he grows up. That's somebody who studies insects. He has the biggest, neatest butterfly collection that I've ever seen. He had invited me to help him catch some new specimens, and that's how this whole adventure started.

You probably know Jasper as Sherlock. When I wrote the story of how he solved the Willoughby bank robbery, people started asking me to tell the story of the assassination attempt on the governor, which had taken place nearly a year earlier. That's this story. When Jasper solved the case, everyone started calling him Sherlock, and—well, I'm getting ahead of the story.

"How did we pick up those voices?" I asked. "Were they using walkie-talkies, too?"

Jasper shook his head. "I think we picked up a telephone conversation. They were probably using a cordless phone, or even a cellular phone."

"Then how did we get them on our walkie-talkies?" I asked.

"These units have three different frequencies," he explained. "You may have noticed the ABC switch on the back. I modified channel A so that it's on the same frequency as the Willoughby police department. I also modified the B channel to give us a super-secret frequency. I didn't want someone else to pick up our conversations if they have a walkie-talkie. Apparently, I used the same frequency as someone's phone."

"What's this for?" I asked, pointing to an orange button on the face of the radio in my hand. "And what are all the Morse code symbols for?"

"I'll explain it to you later," he promised. "We need to hurry to the police station right now. Chief Ramsey needs to know about the plot to kill the governor, if that's what it really is."

We reached our bikes just then. Jasper's blue dirt bike was lying in the grass right beside my pink ten-speed. "Sorry I was late, Penny," he apologized. "I had to get new batteries for the walkie-talkies."

"No problem," I muttered. "I'm used to falling out of trees, ruining my clothes, and nearly getting killed. I was glad to do it for you."

Jasper ignored my sarcasm. "I'm glad it's Saturday," he said, as we climbed on our bikes. "I need to get home this afternoon and finish that report for Miss Wiggins. Have you got yours done yet?"

"No, I haven't!" I snapped. I was still just a little upset with him. "It's really not fair! We've

only had two weeks of school, and Miss Wiggins is assigning reports already! She's gonna be a real bear of a teacher!"

Jasper shrugged. "How do you think she earned her reputation as the toughest teacher in the school?" He pedaled away with me right behind him, then turned and called over his shoulder, "That's usually the kind of teacher you learn the most from, anyway!" I pedaled furiously to keep up. My mind wasn't on Miss Wiggins. I was thinking about the two sinister voices on the walkie-talkies and the plot to kill Governor Bradley. Cold chills were running up and down my back in spite of the warm September day.

We reached the edge of town, and I finally caught up with Jasper. Willoughby is a dinky little town of 1,848. We pedaled past a little green sign that tells you that. (The part about 1,848, not the dinky part.) We have three churches, two grocery stores, and three filling stations. I think the last excitement we had in Willoughby was back in 1989 when old Mrs. Perkins dropped a gallon jar of pickles in Smedley's Grocery. Living in this little town is about as exciting as writing a book report.

Jasper suddenly skidded to a stop, and I swerved just in time to keep from rear-ending him. "Quick!" he hissed, in a loud whisper. "Down this alley!"

I glanced up the street and saw the cause for Jasper's alarm. About a block away, riding right

13

toward us, were Brandon Marshall and two of his buddies. Brandon is nothing but trouble. He's failed a couple times, so he should really be in eighth grade. He's a big, chunky kid, as tall as the teachers are, with huge arms and shoulders like a weight lifter. His blond hair is cut in a crew cut, and he wears an earring in one ear. The kids at school are all afraid of him.

Jasper and I made a quick left turn into the alley, but we were too late. Brandon had seen us. Brandon and his two goons made a quick right turn onto a street half a block away to try to head us off. I suddenly realized that Jasper and I were in big trouble. Brandon hadn't earned his reputation by being nice to kids.

Halfway down the alley, Jasper stopped suddenly, his rear wheel sliding and shooting gravel. I couldn't stop in time, and my bike collided with his. He jerked his bike around, then took off in the opposite direction. "This way!" he called. "We'll lose them!"

In a flash, I had my own bike turned around and was pedaling furiously after Jasper, my legs pumping like the pistons on a steam engine. I caught up to him as we turned onto the street. A block-and-a-half later, we heard a shout and glanced over our shoulders. Brandon and the other bullies had just turned onto the street. "We can make it!" Jasper puffed. "The police station is only two blocks away!"

Even with our big lead, they almost caught us. We reached the police station just a hundred yards or so ahead of them, parked our bikes, then dashed for the door. "Hey, Spider-Legs!" Brandon called to Jasper. "Wait up! Hey, Freckles!"—He was talking to me—"we want to talk to you!"

We made it inside the door as they rode past. Brandon kicked Jasper's bike over as he flashed past, then the three disappeared down the street. I don't know what they would have done if they had caught us, but I was shaking like a June bug caught in a black widow's web.

The police station is a tiny little block building with a small reception area in the front and two dinky offices in the rear. All three officers of the Willoughby police force were in the front office when Jasper and I walked in.

Chief Ramsey is a middle-aged man, short and stocky, with a little gray fringe around the sides of his head. I've never seen a man who sweats so much. His feet were propped up on the dispatcher's desk when we walked in, but his light blue uniform shirt was dark with perspiration, and he was mopping his face with a dirty white handkerchief. I'd hate to see how much he'd sweat if he were doing some work.

The two lieutenants are both tall. The younger one, Officer Bill Thomas, is blond, good-looking, and single. He's nice to all the kids in Willoughby. The other officer, Clark, reminds me of a rain cloud

ready to storm. He has dark skin, dark hair, and dark eyes, and he walks around with a constant frown on his face. I don't think I've ever seen him smile. I always try to stay out of his way.

We sauntered up to the counter by the front door, and Officer Bill came over. "May I help you?" My heart was pounding. My, he's good-looking!

"Sir, we need to talk to Chief Ramsey," Jasper told him politely. "It's important!"

Chief Ramsey heard him, and he sighed deeply as he pulled his feet off the desk, giving us a why-do-I-have-to-bother-with-kids look as he walked over to the counter. "Yes?" he said in the kind of voice that would be handy to have around in case one's air conditioner ever went kaput.

Jasper quickly told him what we had heard on the walkie-talkies. Chief Ramsey drummed his fingers on the counter and did his best to look bored as my friend talked. The other two officers stood on either side of the chief, listening to our story. As Jasper related what we had heard, I butted in from time to time, just to make sure he had the story straight.

When we finished, Chief Ramsey smiled a horse-faced condescending smile. "Thanks, kids," he said. "You've done your duty. Now, run along and play."

Jasper knew immediately that the chief was not taking us seriously. "Listen, sir!" he pleaded. "This was for real! These people are planning to—"

The chief cut him off with a wave of his hand. "I said we'd take care of it, boy! Now, run along. We have work to do."

We meekly left the station, but I was boiling inside. Someone was planning to kill Governor Bradley, and the police didn't even care! Nobody takes kids seriously these days.

Jasper frowned at me as he picked up his bike from the sidewalk. "It's up to us, Penny," he said. "Someone is planning to assassinate Governor Bradley, and it's up to us to stop them!"

The cold chills were running up and down my spine again as we pedaled away from the police station.

3 – Jasper's Information

Monday morning I sat in social studies class trying desperately to stifle my yawns or at least hide them behind my hand. Church had gotten out late last night, and I had stayed up even later to finish my report. Mom had to call me three times to get me up for the school bus.

I was struggling just to keep my eyes open. But every time Miss Wiggins glanced in my direction, I sat up straight and tried to look like I was involved in what was happening in class.

We were studying the three branches of state government: executive, legislative, and judicial. Miss Wiggins sat stiffly behind her big desk, her back ramrod straight, her cold, stern eyes scanning the room as the students took turns reading from the textbook. With her tall, thin figure, tortoise-shell glasses, and graying hair pulled back into one of those old-fashioned buns, she looked exactly like an old time school marm. You know the look.

Christy Evans was reading. "The governor is chief officer of the executive branch of state government . . ."

My mind left the classroom and wandered back to the butterfly-catching expedition of Saturday, or rather, to the strange message we had picked up on

18

the walkie-talkies. Who wanted to kill the governor? Why wouldn't the police take us seriously? How in the world could Jasper and I ever hope to stop the assassins? Who were these people, where did they live, and what did they look like? And who was the Sidewinder?

My mind snapped back to the present as I suddenly realized that it had grown deathly quiet in the classroom. The textbook reading had stopped, and it was so quiet you could have heard a gnat sneeze. I slowly raised my head. Miss Wiggins was no longer sitting behind her desk; she was standing stiffly beside it, and I could tell by her demeanor that someone was in serious trouble.

The students waited silently, paralyzed with fear. I held my breath. Sweat trickled down my back. The teacher had realized that I was not paying attention, and boy, was I in for it! I was about to experience the wrath of the dreaded Miss Wiggins.

But her cold, hard eyes were not fixed on me. Her attention was on Jasper. "Mr. Jones," she said slowly, deliberately, "please stand to your feet."

With a helpless, appealing look on his thin face, my friend slowly stood beside his desk. The rest of the class, even those who were not his close friends, flashed him looks of sympathy. Brandon Marshall snickered behind his hand, but Miss Wiggins chose to ignore it.

"Mr. Jones, would you be so kind as to explain why your book was not open? We are reading

chapter three, Mr. Jones, and we are doing it as a class. Why were you not reading with us?" Her eyes flashed fire as she said the words. I cringed inside for my friend.

"I—I was f-following along," Jasper stammered.

Miss Wiggins froze for a moment, then slowly crossed her arms in front of her. "Please repeat that, Mr. Jones," she said icily. "I really don't believe you said what I thought you said."

"I was following along as the other students read," the boy explained again.

"Mr. Jones, your book was not open," the enraged teacher snapped. A mental picture of Jasper's insect-mounting board suddenly flashed into my imagination, only this time the insect was Jasper. He was about to be skewered by the wrath of Miss Wiggins.

But Jasper didn't seem to realize the predicament he was in. The nervous edge was now gone from his voice, and he spoke calmly. "I have the book memorized, Miss Wiggins," he explained. "I was following along in my memory."

It was just too much. Miss Wiggins, veteran of thirty years of teaching, master of every classroom situation, had never heard that line in all her teaching experience. She was aghast at the brashness of Jasper's lie. The rest of the class watched in petrified silence. Even Brandon was quiet.

Miss Wiggins stiffened suddenly as Jasper spoke, and her breath made a little sniffling sound in her nostrils as she gasped in astonishment. She could not have been more shocked if Jasper had had the audacity to slap her in the face. Her face went pale, her eyes grew even colder and harder, and her lips were actually trembling with rage.

But then, she recovered, and once again, asserted herself as master of her classroom. She walked slowly toward Jasper, each high-heeled step on the hardwood floor echoing across the silent classroom like the executioner's footfalls on death row. She only took six steps, but it seemed like it took a full five minutes.

She stopped halfway to Jasper's desk. "Then suppose, Mr. Jones," she said, with a cold, hard smile, "that you begin reading the next page from memory." She adjusted her glasses, then folded her arms again and stood waiting, secure in the knowledge that her prey was now at bay.

"Yes, ma'am," Jasper said politely. "Where were we?" He thought for a moment, then—"Oh, yes. The three branches of government: executive, legislative, and judicial, form a check and balance system that ensures that no department is vested with absolute power. This check and balance system—"

Miss Wiggins gave a sharp cry, then whirled and snatched the textbook from the desk of Angela Parker, who was seated two seats ahead of Jasper.

21

Her mouth actually fell open as she followed along in the book while Jasper quoted from memory. My eyes dropped to the page of my own book, and believe it or not, Jasper was quoting the text—word for word!

He rattled off a page and a half, then stopped as Miss Wiggins weakly held up one hand. Her head was lowered, and her eyes were closed. I don't think she had ever experienced such a shock in all her teaching career. Angela Parker's book struck the floor at Miss Wiggins' feet.

"That's enough, Jasper," she said, in a quiet voice. "Class, close your books, and head out for recess. You have twenty minutes. I want the entire class out on the playground."

As we filed from the room I glanced over my shoulder. Miss Wiggins was seated at her desk, looking very old, very tired, and very vulnerable. I felt sorry for her. Angela's book was still on the floor.

Once we were outside, the entire class crowded around Jasper. "Do you really have all your textbooks memorized?" Candy Meyers asked, with a note of awe in her voice. "No wonder you make straight A's!"

"Way to go, Spider-Legs!" Brandon shoved his way through the cluster of students until he was face to face with Jasper. "You really showed old battle ax Wiggins!"

My friend shook his head. "Brandon," he said, "I didn't do it to be disrespectful. I really was following along in the text, but she just didn't believe me."

"Do you really have all our textbooks memorized?" Candy asked again.

Jasper shrugged. "I usually memorize the books the first week of school," he said casually. "That way, I don't have to carry them home every night."

I stared at him in astonishment. He was so nonchalant, as though the amazing memory skills he had just displayed were routine, something that anyone could accomplish. The other kids in our class were also regarding him with looks of new respect.

The rest of the day went smoothly. When we came back in from recess, Miss Wiggins seemed to have her old fire back. But I noticed that from time to time throughout the day she threw an uneasy glance at Jasper. He didn't seem to notice.

The dismissal bell finally rang, and everyone eyed Miss Wiggins, waiting for her nod of permission. She sat for a moment, lips pursed, studying her grade book, while we shuffled our feet impatiently. Finally, she closed the book, lifted her head, and regarded the class with the familiar cold stare.

"We have a thief in our midst," she informed us, pronouncing each word slowly, cuttingly, almost as if she were biting the end off each word. Her

statement brought a sudden hush over the room. She paused, following her announcement with a moment or two of silence to make the desired impact on us.

"Valuables have been taken from my desk, and two students have informed me that they also are missing certain items." She paused again, and the silence that followed was unbearable. Even though I was innocent and didn't know who the thief was, I suddenly found that I could hardly breath. Fear settled on me like a heavy weight. I felt dizzy, almost sick, and I knew that my classmates were experiencing the same thing. Miss Wiggins knows how to play with your emotions.

Without speaking, she let her stern gaze fall upon one student after another. I noticed that all the students dropped their heads when their eyes met hers. When she came to me, for some reason, I did the same.

When she had made eye contact with each member of the class, she spoke again. "I intend to deal severely with the thief," she said, and there was no doubt in my mind that she meant every word. I felt pity for the poor soul who had been foolish enough to steal and invoke the wrath of our fierce teacher.

"Class dismissed," Miss Wiggins said suddenly, and twenty-two frightened young people made a beeline for the lockers in the hallway. When

we stepped outside, the brightness of the afternoon sunshine was like a release from prison.

As I was heading for the bus, Jasper caught up with me. "Do me a favor, would you," he asked. "Go with me again to the police station. Please?"

I frowned at him. "What for? They just chased us out last time."

He looked up at me imploringly. "Please? We've gotta talk to the chief again. I know he didn't take us seriously last time. But I've got some new information that may change his mind. I hate to go alone. It would be good to have you there, too."

I shrugged. "OK. I'll go."

He smiled as we climbed on the bus. "Thanks, Penny. I'll come by with my bike about ten minutes after you get home. I appreciate it."

He followed me to a seat on the bus, and we discussed the thefts in our classroom. "Do you think it is Brandon?" I asked. "He seems like the kind of person that would do a thing like that."

Jasper shook his head. "It's not Brandon."

I looked at him in surprise. "How do you know?"

He shrugged. "It's not Brandon," he repeated. "I know who it is, but I won't name the guilty party until I have the proof I need."

I shook my head in disgust. I knew that he had no more idea about the identity of the thief than I did, and that he was just bluffing. "How do you

know who it is?" I challenged. "Are you some sort of detective?"

He suddenly seemed embarrassed, but he nodded shyly. "I am a detective, but I don't tell everyone. Keep it a secret, OK?"

I turned abruptly away from him and pretended to be interested in the scenery passing by the bus window. This little jerk might be endowed with the most remarkable memory I had ever seen, but this was too much! A detective! I decided right then that I was much too grown up for such childish games. I would go to the police station with him just this once, but only because I had already promised. After this, he could play his little detective games by himself.

Sure enough, exactly ten minutes after I climbed off the bus, Jasper came riding down the gravel lane that leads to my house. I hopped on my bike and followed him back down the lane without speaking.

He looked over at me. "You seem upset," he observed.

I tossed my head. "Not really."

"Thanks for coming with me," he said.

"It's all right," I replied curtly.

He glanced at me again, raised his eyebrows for an instant, and rode on in silence. Moments later, we passed the little green city limits sign, and we were in town.

"Hey, Spider-Legs!" a husky voice suddenly called, and my heart sank. Brandon and his gang! They appeared out of the oleanders at the side of the alley, pedaling hard, riding straight at us. Brandon was in the lead, his two goons right behind him for backup.

Brandon rode directly into Jasper's path. My friend swerved hard to avoid a collision with the other bike, and at that moment, the bully's foot lashed out, striking Jasper's handlebars. Jasper's front wheel jerked violently to one side, throwing him onto the asphalt. The three bullies rode off laughing. "See ya later, Spider-legs!"

I braked hard, dropped my bike against the side of the curb, and ran back to Jasper. He was just picking his bike up out of the street. The side of his face was skinned badly, and a bit of blood was just beginning to run down onto the collar of his shirt.

"Ooh!" I gritted through clenched teeth. "I'd like to wring Brandon's neck! Look what he did to you! And suppose a car had been coming!"

Jasper wheeled his bike to the curb, dropped the kickstand, and dabbed at the side of his face with a Kleenex. "He needs the Lord, Penny," he answered, and I stared at him in amazement. There didn't seem to be the slightest trace of anger or resentment in his voice.

"Brandon's mother is an alcoholic," Jasper said, "and he doesn't have a father. He acts the way

he does because he needs the Lord. He probably doesn't even know the meaning of the word love."

☙ ☙ ☙

I was disappointed to find that Chief Ramsey and Officer Clark were the only ones at the police station. Officer Bill was out on patrol. The chief looked up wearily from his desk as we entered. "You again! What do you want now?"

Jasper walked right into the little cubicle. "I have some information that I thought you ought to receive," he told the lawman cheerfully. "Governor Bradley is scheduled to visit Willoughby a week from Saturday. I figure that's when the assassination attempt will take place."

Chief Ramsey frowned, then glanced at Clark. "How about it?" he asked. "Do we have anything on a visit by the governor?"

The tall, dark-tempered officer shook his head. "Not that I know of," he replied.

Ramsey turned back to us. "I'm through with your little games," he told Jasper sternly. "Get out! We have work to do! The next time you show your faces in here, I'm calling your folks!"

To my surprise, Jasper stood his ground. "Call the governor's office," he suggested. "They can validate my information."

The chief just waved his hand at Clark, who was now standing in the doorway. "Call," he said impatiently. "Then chase these kids out."

Two minutes later, the tall officer stood in the doorway again. "It's true, Chief!" he said incredulously. "Governor Bradley is coming here! We should have been notified, but there was some sort of an oversight."

The chief turned to Jasper. "How did you know about this, Son?"

My friend just shrugged. "I'm a detective," he explained. "I have my sources."

Chief Ramsey laughed right in his face. "A detective!" he snorted. "Clark, get a load of this! This kid's a detective!" He wiped his eyes. "Give the man an application," he said, still chortling. "I'm sure we'll want him on the force!"

For some strange reason, I suddenly found myself squarely on Jasper's side. "He is a detective!" I heard myself blurting out. "And a good one, too!"

"Oh really, Missy?" The chief turned back to Jasper. "And what makes you a detective, boy?"

"I've studied law enforcement and techniques of investigation," Jasper replied evenly. "I've trained my powers of observation, and I have a deductive mind. I know how to conduct an investigation."

"Oh, really?" Chief Ramsey was amused by my friend's answer. "Why don't you conduct an

investigation on me? I've only been here two years. See what you can find on me."

Jasper nodded. "OK," he agreed. "Tomorrow's Tuesday. I'll bring the information to you tomorrow afternoon."

The chief stood up, and Officer Clark ushered us to the door. I'm sure Chief Ramsey thought that was the end of it, but he was in for a big surprise. Little did he know just what amazing detective abilities my skinny friend possessed.

4 – The Fossils

The next morning I waited at the bus stop, glancing from time to time at my watch. Funny that Jasper wasn't here yet. He's always early, but it was nearly time for the school bus, and he hadn't arrived.

I heard the low roar of the bus making its way up the hill, and my heart sank. Jasper was going to miss the bus! But at that moment, a small figure came tearing down the road toward me. Sure enough, it was Jasper, with a big bandage on the side of his face. He reached the bus stop just ahead of the bus. For a few seconds he stood with his hands on his knees, head down, trying to catch his breath. We heard the hiss of air brakes; the big yellow bus slowed to a stop and the door opened. I followed Jasper to a seat.

Jasper was still breathing hard, but he seemed immensely pleased about something. "Come with me to the police station this afternoon, Penny," he said. "I think we'll have some fun."

I shrugged. "I guess I can."

That must have been one of the roughest Tuesdays I have ever spent in school. My classmates all seemed tense—perhaps because of yesterday's announcement regarding the thefts—

31

and Miss Wiggins seemed edgier than usual. At morning recess, I went out to a secluded corner of the playground and walked around, just to be away from people.

After lunch, we always have science. This month, we were studying a unit on origins—you know the beginning of life, of the universe, and stuff like that. We were in a chapter that dealt with the geological record of the earth's history, fossils and stuff. Miss Wiggins was having different students read aloud from the text.

She called on Brandon. "Mr. Marshall, read next, please."

Brandon stumbled through the words. "A study of geology provides valuable clues as to the origins of our universe, our planet, and of life itself. The earth's crust provides the only reliable record of prehistoric events and of life as it existed before man appeared. The fossil record indicates that life forms appeared slowly and gradually evolved into the complex forms we find inhabiting our planet today."

I sighed. Here was all this evolutionary stuff again. Mom and Dad had taught me that God made the earth and all life on it. I've always believed that. But, why doesn't science agree with the Bible? It was a real problem for me. If God really made the earth, then why don't the fossils show it?

"Yes, Mr. Jones?"

I glanced up from the textbook. Miss Wiggins had just called on Jasper, and he lowered his hand. "I believe that God created this universe, Miss Wiggins, and all forms of life on our planet earth. Evolution never took place."

Miss Wiggins smiled that cold, fishy smile of hers, but her eyes were cold and hard. "That's fine, Mr. Jones," she replied coolly. "Everyone is entitled to his or her own beliefs."

She raised her voice. "But right now, Mr. Jones, we're studying science, not religion. Science has provided us with reliable information as to the origin of life."

But Jasper didn't give up. I admired his courage as he stood his ground. "Why does the textbook claim that the fossil record proves that evolution took place?"

Miss Wiggins was getting steamed. Her lips were drawn into tight, straight lines as she answered, "Because, Mr. Jones, the fossils do indicate that. The fossil record is our key to the past, and the fossils show clearly that evolution took place. You're entitled to your religious views, Mr. Jones, but science disagrees with you."

Jasper shook his head. "No, ma'am, it doesn't!"

"I beg your pardon?" Miss Wiggins was actually trembling now. I think she was as angry as she had gotten yesterday.

But Jasper wasn't intimidated. "Where are all the transitional life forms, Miss Wiggins?"

"The what?"

"The transitional forms," my friend repeated. "Our scientists have found millions of fossils, but never any transitional forms. If one form of life did evolve into another, why is there no fossil record of the change? If amphibians did evolve into reptiles, or reptiles into birds and mammals, shouldn't we find creatures in the process of making the change?

"There should be an abundance of transitional forms—fossils of creatures half reptile, half mammal. There should be creatures half reptile, half bird. For every life form on earth today, there should be thousands of transitional forms. But there are none! I say that the fossil record speaks for creation."

Miss Wiggins had had enough. "Mr. Jones," she said slowly, "if you say another word during this class period, you're going straight to Mr. Murphy's office! Not another word! Do I make myself clear?"

She took a deep breath and looked around the quiet classroom while trying to smile. "Now, where were we?"

That's just great, Miss Wiggins, I thought. *If you can't answer the argument, just tell your opponent to be quiet.* I looked at Jasper with new respect. I was glad he had the courage to speak up for creation.

I really didn't hear another word of that class period. I was busy thinking through what Jasper had

said. Our textbook claimed that the fossil record proved evolution, but apparently that wasn't true at all. But then again, why would the book even make that claim if it were obviously false?

The bell finally rang that afternoon, and I gathered my books, stopped at my locker, then hurried to the bus. Jasper was saving a seat for me. I plunked my books down in the center of the seat. "Must be nice not to have to carry books home every night," I said to him. He just smiled.

"What are you gonna do at the police station?" I asked, but the look on his face told me that I was going to have to wait.

"I did a quick investigation on Chief Ramsey," he told me. "I think he'll be surprised. I'll bike over to your house." I begged him to tell me more, but that was all he would say.

My pretty, curly-haired mom greeted me as I walked in the front door. "Hi, Penny!" she smiled, her brown eyes twinkling. "How was school today?"

I hugged her. "It was rough," I complained. "Miss Wiggins was ready to bite everyone's head off!" I told her about the science textbook, and about what Jasper had said. She laughed when I finished.

"That boy's something else, isn't he?" she said, shaking her head. "I'm glad he stood up for the things of the Lord. Did you say anything?"

I shook my head. "What could I say? Jasper said it all! When he got through, he made evolution look like a big lie! Even Miss Wiggins couldn't argue with him, so she just told him to shut up!"

Jasper knocked on the door just then, and I hurried out to meet him. We pedaled to the station, relieved that Brandon and his friends didn't make an appearance. "He's probably giving my face a chance to heal before he messes it up again," Jasper cracked as we parked the bikes. I laughed, and he held the door for me.

Chief Ramsey looked up as we entered. "You two again? Is this becoming a daily thing?"

We walked up to the counter, and the two lieutenants appeared in the doorway of one of the little offices. I was glad to see Officer Bill. Mrs. Elgin, the middle-aged secretary who doubles as dispatcher, was at the coffeemaker, fixing Chief Ramsey a cup of that horrid-tasting, growth-stunting brew.

Jasper smiled at the chief. "I did a bit of an investigation on you," he said. "I didn't find a whole lot, but then, I've only had a day, and most of that was spent in school."

The heavy lawman laughed. "Oh, yeah," he said. "That detective bit again." He was being scornful toward Jasper, and it kind of bugged me. But my friend just smiled at the chief. I'm sure he realized that he was being laughed at, but it didn't seem to bother him.

"Your full name is John David Ramsey," he told Chief Ramsey. "You're fifty-three years old, and you reached the rank of lieutenant while serving with an intelligence unit in the U.S. Army. You drew a disability pension after being wounded in action in Vietnam."

I stared at Jasper, but my surprise was nothing compared to Chief Ramsey's. His mouth actually fell open. But Jasper had a lot more. "You don't smoke, and you had a kidney operation four years ago. You drink diet Sprite, and you're an ice cream addict. Your favorite is Turkey Hill black raspberry."

The lawman frowned. "OK, kid, OK. You've been talking to my wife."

Jasper shook his head. "Sir, I've never met your wife."

"Then who did you talk to?" The question was almost a growl.

"Nobody, sir," my friend answered. "You mowed the grass last Saturday, and you had quite a bit of trouble with the lawn mower. You like to bowl; in fact, you're quite good at it. You're a Dallas Cowboy fan, and you're a Democrat. You have a sister living in Wisconsin, and your brother in California has cancer."

By now, I could see that the chief was quite disturbed. "How do you know all this?" he asked.

Jasper grinned. "I'm a detective," he answered simply. "There's more, but you may not want the

lieutenants to hear it. Let's talk about your wife."
Chief Ramsey glanced nervously at his two officers
as Jasper continued. The grins on the lieutenants'
faces told me that they were enjoying the show
immensely.

"Your wife is forty-nine," my friend went on.
"She smokes Virginia Slims, but she's trying to
quit. She's a diabetic, and—"

The chief cut him off. "That's enough, Son,
that's enough! You made your point. But I'd like to
know how you got all this info on us. It's uncanny."
He ran a big hand across his mouth, and I noticed
that his fingers were trembling. He looked like he
was going into shock.

Jasper leaned across the counter. "Now, about
the plot to assassinate Governor Bradley—"

I thought Chief Ramsey was going to strike
him. His face reddened as he snarled, "I told you
before, kid, quit messing in police business! If
there's a plot to wipe out the governor, we'll take
care of it! I don't know what kind of games you've
been playing with me here, but enough is enough!
Now—make yourself scarce!"

He pointed to me. "You too, Missy!"

Jasper turned to me. "I guess we had better get
going now, Penny."

We walked to the door, and Jasper turned back
to the chief, who was still leaning against the
counter. "Have a good vacation next summer,

Chief," he said. "The Bahamas will be really pretty the first week of June."

The chief's head jerked up in surprise, and I knew that Jasper had scored again. The lawman nodded weakly. Jasper waved to Mrs. Elgin and the two grinning lieutenants, and then we headed out the door.

5 – A Weird Source of Information

Jasper's performance at the police station was the most remarkable thing I had ever seen. When we reached the bikes, I turned to him in amazement. "How did you know all that?" I asked. "Chief Ramsey was about to go into shock! How in the world did you find out all that about him?"

Jasper turned his palms up in a casual gesture. "Chief Ramsey sees me as a little kid playing detective games," he answered. "I just wanted to show him that I'm a detective—for real."

I laughed. "I think you made a believer out of him," I giggled. "Did you see his face when you told him that part about his military service? I thought he was going to drop his teeth!"

We jumped on the bikes and pedaled away, but I was dying with curiosity. "Come on, Jasper, tell me!" I finally pleaded. "How did you do it?"

"Do what?"

"Come on, you know what! How did you find out all that about Chief?"

He looked at me with a funny expression. "Penny, I'm a detective. You don't really expect me to divulge that information, do you?"

"Yes," I said. It was the only answer I could think of.

We pedaled in silence for a couple of minutes. Finally, he looked over at me and said, "I'll give you a hint. This is Tuesday. I did every bit of my sleuthing this morning before school. What does that tell you?"

I stared at him blankly. "It doesn't tell me anything."

He seemed frustrated. "Penny, think! What happens every Tuesday?"

I said I didn't know, and we rode along in silence. I was still eaten up with curiosity. What would Tuesday have to do with Chief Ramsey? We reached the lane to my house, and I turned my bike into it. Jasper braked to a stop out on the main road. "See you tomorrow!" he called.

I couldn't let him go without finding out. "Jasper, please," I coaxed. "I'm begging you! How did you know all that stuff about Chief?"

"What happens on Tuesday?"

"I don't know!"

"And every Friday."

I was more frustrated than ever. "Jasper," I said, "the only thing that I know of that happens every Tuesday and Friday is the garbage collection! Now tell me!"

"You've got it!" he said triumphantly.

"Got what?" I was more confused than ever.

"The garbage is collected in Willoughby every Tuesday and Friday! Now you know how I got my information!"

A light was beginning to come on. "You talked to the garbage man?" I guessed.

"No, Penny, no!" Jasper almost shouted. "One of the best sources of information about anyone is in the things they throw away! You can read a person's garbage like you read a book!"

I laughed as he wheeled his bike across the road to me so we wouldn't have to shout. "You went through Chief Ramsey's garbage this morning? What if someone had seen you?"

Jasper leaned on his handlebars. "I went down to the chief's house with a plastic garbage sack full of wadded-up newspapers," he said. "I took a sack of his garbage, then dropped my sack into his trash can, so he wouldn't realize that some of his garbage was missing. I took his garbage over to the park to sort through it."

I laughed at the mental picture of Jasper on his knees digging through the Ramsey's garbage. "But how could you learn anything from looking at his garbage?" I asked. "Like the part about how old he was, or that he was in the army?"

"I found a carbon-copy of a life insurance application he had filled out," he explained. "It told the age of both the Ramseys, that Chief was a non-smoker, and that he had gone through kidney surgery."

"What about his being in the army?" I asked. "How did you know that?"

"That was just as easy," he laughed. "There was a check stub from his monthly disability check, as well as a letter explaining a slight change in VA benefits. I figured since he wasn't old enough to have been in Korea, he must have been wounded in Vietnam."

I shook my head in amazement, then laughed. "You make it seem so easy!"

He laughed with me. "It is, Penny!"

"Did the VA papers give his full name?" I asked.

The young detective shook his head. "They were just addressed to John D. Ramsey. I found a letter from his sister in Wisconsin, and in it she called him 'John David' several times. She also mentioned their brother in Los Angeles with cancer."

"What about the trouble with the lawn mower? And the part about the diet Sprite and the black raspberry ice cream? And how did you know he was a Dallas Cowboy fan?"

"It was all in the can!" Jasper laughed. "I found a spark plug, and I figured it came from a lawn mower, since you never replace just one spark plug on a car. Then, the broken starter rope in the can confirmed it. There were several diet Sprite bottles in the garbage, and the diet Sprite bottle at the police station told me he was the one who drinks it.

I found two Turkey Hill black raspberry cartons in the trash. That told me that he had emptied them both since Friday, when the garbage was last collected. Mrs. Ramsey is a diabetic, so I knew she wasn't the one eating it. I'd say he's an ice cream addict."

"How did you know he's a Dallas Cowboy fan?"

"Bumper stickers on both cars in the driveway."

I shook my head again. I don't guess I could learn anything about anybody by going through his or her garbage, but when Jasper explains it, it all seems so logical, so easy.

"One more thing," I said. "What about the bowling? How did you know that he likes to bowl?"

"There was a whole row of bowling trophies in the front window," he explained.

There were several more bits of information that I wanted to ask him about, but I decided to keep my mouth closed. I had already asked enough questions for one day. I didn't want to look too ignorant. We said good-bye, and he pedaled off.

6 – The Thefts Continue

Miss Wiggins was visibly upset as she faced
our class the next morning. The pledge of
allegiance had been recited, and Mr.
Murphy's announcements over the public address
system were finished. We had just started to get out
our math books when Miss Wiggins stood to her
feet with a look on her face that made everybody
freeze. We knew instantly that something was up.

"Students," she began, "I'm sorry to inform
you that the thefts are continuing in our classroom.
Several of the game disks were missing yesterday
from the computer learning center, and now twenty
dollars has been taken from my desk."

A heavy, uneasy silence prevailed. Miss
Wiggins looked from one anxious face to another
for several minutes without speaking. The
unbearable tension made me squirm in my seat,
even though I was innocent. Finally, she spoke
again, and her cold, hard voice was actually a relief
from the painful silence.

"Mr. Murphy knows all about this," she grated.
"He and I intend to get to the bottom of this, and
when we do, the thief will wish—" She paused,
leaving the sentence unfinished for effect.

"Yes, Miss Cantrell?"

Audra Cantrell lowered her hand. Audra is a slender blond, always well dressed, and easily the prettiest girl in our class. "I'm missing two Dark Vengeance tapes," she said softly. "They were in my desk after school yesterday."

Miss Wiggins nodded grimly, and I realized that Audra's news was no encouragement to her. It suddenly occurred to me that the most frustrating thing about the thefts for our teacher was that she did not know who the thief was. She was used to having total control in the classroom, and now, this was a situation that she couldn't handle.

Audra raised her hand again, and Miss Wiggins merely nodded in her direction, indicating that she had permission to speak. "Couldn't you and Mr. Murphy just search our desks and lockers?" she suggested. "If the thief still has the stuff here at school, now would be the time to find it."

The teacher nodded. "Not a bad idea," she agreed. "I'll discuss it with Mr. Murphy."

"Now!" Audra spoke up. "Search us now, before the thief has the chance to ditch the goods!"

Miss Wiggins paused a moment, then quickly decided that Audra had a good idea. She hurriedly wrote a note, then sent Audra to the office with it. I noticed as Audra left the room that she took her purse with her.

The class grew quiet as Mr. Murphy entered the room just moments later. The game was getting serious. Our principal is a tall man, bald-headed,

and sort of pear-shaped. He's mean-tempered, and most of the kids try to stay out of his way.

"Students, you'll follow Miss Wiggins out into the hallway," he instructed us in a deep bass voice. "There will be absolutely no talking. Miss Wiggins, please line the kids up against the wall opposite the lockers. We'll have them open their lockers one by one. If the lockers are clean, we'll return to the room and search the desks."

Trisha Adams was first. Her hands shook as she turned the dial on her combination lock. She was so nervous that she didn't get the combination right the first time and had to try twice more. While she was working on the lock, I could see a bright yellow sweatshirt through the little vents in her locker door.

Miss Wiggins and Mr. Murphy looked through the contents of her locker. It was just the usual stuff—gym shoes, sweat shirt, hairbrush, etc. When the locker had been thoroughly searched, she was allowed to return to her place in line.

One by one, Miss Wiggins called us to our lockers alphabetically. When my turn came, I was just as nervous as Trish had been, even though I had nothing to hide. It was kind of embarrassing to have all my stuff displayed before the whole class.

Several kids opened their lockers after me, but they too were clean. The locker search was producing nothing, and we were already halfway through the alphabet. And then came Brandon Marshall's turn.

Brandon unlocked his locker, then stood to one side as Mr. Murphy pulled it open. The door swung to one side, and there was a loud gasp of surprise as several items tumbled out and clattered on the floor—two cassette tapes and several three-and-a-half-inch computer disks. I could see inside the locker from where I was standing, and there were two more computer disks along with a crumpled twenty-dollar bill on top of Brandon's gym clothes!

Talk about a shocker! Miss Wiggins, Mr. Murphy, and the entire sixth-grade class stared at the items on the floor, then turned and stared at Brandon.

But the big bully seemed as surprised as anyone. Open mouthed, he gawked at the items on the floor, then glanced into his open locker, and suddenly his shoulders sagged. He turned to Mr. Murphy. "I don't know how these got in here, Mr. Murphy!" he said in a pleading tone. "Honest, I don't!" Talk about an actor! He almost had me convinced.

Miss Wiggins bent over to retrieve the two cassette tapes, but we all knew before she did it that they were both Dark Vengeance tapes. She glanced at them, then handed them to Mr. Murphy, who nodded as he read the labels. He turned with a fierce countenance to Brandon, and the boy protested his innocence again.

But Mr. Murphy wasn't buying the act. He took Brandon by the arm, then turned to Miss Wiggins.

"Brandon will be suspended from school for the day," he said. "Mark him down for an unexcused absence."

Back in the classroom, I sat at my desk thinking through what had just happened. So Jasper was wrong, after all! Brandon was the thief, in spite of Jasper's theories. I was just glad that he had been caught so easily.

"Class, get your lunches, then line up at the door." Miss Wiggins was speaking. "The bus is waiting outside to take us to the museum."

Today was the day for our first field trip! We were going to the Museum of American History down in Spencerville. In the excitement over the message we had overheard on the walkie-talkies and the added drama of the thefts in class, I had totally forgotten the field trip. This could turn out to be a good day, after all. At least, it offered us the chance to get out of class for a while.

The bus bounced down the highway toward Spencerville. Jasper sat next to me on the bus, trying to read a detective novel. After a few minutes, he dropped the book on the seat in disgust. "This guy's no detective," he snorted. "This book was written for morons!"

I shrugged. "You weren't so hot on The Great Willoughby Elementary Classroom Theft Case yourself," I needled. "Brandon was guilty all along. But a certain detective that I know thought that Brandon was innocent!"

He gave me a condescending look. "So you fell for it, too, huh?"

"What are you talking about?" I whispered. "The stuff was in his locker! Are you trying to tell me he didn't do it? Get real!"

"Penny, didn't you wonder why Tina's Walkman wasn't in Brandon's locker? It was stolen yesterday, too! And what about Michael's stop watch, or Tony's video game? Why weren't they in Brandon's locker?"

I shrugged. "He already took them home."

Jasper shook his head. "No, Penny. The stuff in Brandon's locker was planted! Brandon never stole it!"

"That's impossible!" I argued. "No one else would have the combination to his locker!"

"They didn't have to."

"Then, how did the stuff get in there?"

"The real thief slipped it into Brandon's locker through the vent slits in the door. She didn't even have to open the door!"

"She?" I echoed. "Just who do you think the thief is?"

Jasper glanced around to make sure that no one was listening, then leaned slightly closer. "Audra," he whispered.

"Audra Cantrell? Jasper, you're crazy! Audra's dad is rich! Why would she steal?"

My friend shrugged. "Just for kicks, maybe. How should I know? But anyway, she's the one. I

want you to help me lay a trap for her. I'll tell you more about it later."

He sighed. "I just wish that setting a trap for Governor Bradley's would-be assassins could be this easy."

7 – Museum Visit

The bus noisily pulled up in front of the museum. Mr. Wilson sat with his foot on the brake, looking bored, while Miss Wiggins stood beside him and delivered the usual lecture about following the rules and the horrible fate awaiting any student who was foolish enough to even consider an infraction. Finally, she finished, and we walked single file into the building.

The first exhibit we viewed was probably the best in the whole museum. It was from the pioneer period of our history, and the displays showed how the Indians and settlers had lived back in those days. Life-sized teepees made from real buffalo skins were set against a backdrop of real trees and prairie grass, with painted purple mountains in the distant background. There were real log cabins and prairie sod houses, life-sized wax figures of Indians and settlers, and even a real horse, stuffed and mounted. The horse was so real that at first we thought he was alive. Some of the kids watched him for several minutes to see if he would move.

I'll remember one scene for the rest of my life. It gives me the chills just to even think about it. We leaned over a short wooden railing, staring in fascinated horror at a room-sized diorama built to

look like the inside of a settler's cabin. There was a wooden bed with a corn shuck mattress against one wall and a trundle bed underneath. A handmade table and chairs sat in the center of the room, and a porcelain pitcher and washbasin sat in the corner on a three-legged stool beside an old-fashioned butter churn. A big spinning wheel stood majestically beneath the one small window. The walls were rough and splintery, since they were made of rough-hewn logs.

A life-sized Mohawk warrior was standing in the doorway of the cabin, holding a rifle in his wax hands. But the figure that immediately captured your attention was the wax warrior with a stone tomahawk in his hand, brutally scalping a wax figure of a bearded white settler while his wax wife and children looked on in helpless terror.

The scene was very realistic; and, needless to say, made quite an impression on us. The museum tour guide explained that the blood flowing down the man's face was actually a special paint that was still wet and would take over six months to dry. The boys were fascinated with the diorama, but most of the girls moved away quickly.

Several minutes later as we left the pioneer exhibit, I glanced back just in time to see our class clowns, Tommy Moore and Nathan Galloway, climbing back through the railing at the scalping scene. I hurried back to the exhibit to see what they had done.

The diorama was not quite as frightening as before, now that the boys had left a touch of sixth-grade humor. The settler's wife, her hands raised in horror, now held a Dixie cup in one hand, and she appeared to be staring into the cup. You got the impression that the cup probably contained a large spider, scorpion, or some other equally repulsive critter that she had just captured.

Her little blond-haired daughter now wore a cheap digital watch on her wrist, and had a bright blue Snoopy bandage on her forehead! The Mohawk warrior at the door was wearing a pair of headphones with wires leading to the broken Walkman on his belt, while his partner with the tomahawk was sporting an Atlanta Braves baseball cap and a pair of fluorescent green sunglasses!

I hurried back to our group, trying desperately to hold back the giggles so Miss Wiggins would not demand an explanation. I still wonder how long the items stayed in the exhibit before the museum people found out and removed them.

We jumped back in time to a prehistoric exhibit with huge dinosaurs and giant insects. Backlighted charts on the walls outlined the various periods in our earth's history, listing strange names like Paleozoic, Mesozoic, and Cenozoic. There were actual specimens of fossils with little captions telling how old each fossil supposedly was. I sighed. Here was all this evolution stuff again.

The tour guide paused before a big chunk of rock that had fossils embedded in it. It was interesting. The fossils were about four inches long, and looked like giant pill bugs.

"Here we have a beautiful specimen with several fossilized trilobites clearly visible," she said in her tape recorder voice. "This rock is from the Paleozoic Era and is about 500 million years old." The kids all oohed and aahed.

"That's older than Miss Wiggins, I'm sure!" Tommy whispered, and the class giggled. Fortunately, Miss Wiggins was standing at the entrance to the room, checking her tour brochure, and didn't hear Tommy's comment.

Jasper raised his hand. "Miss," he said politely, "how do we know that this rock is 500 million years old?"

The tour guide paused with mouth open, as though she just could not believe that anyone would question her canned spiel. She blinked at him, then replied in a voice that you could have made icicles from, "Young man, that's a good question. I'm glad you asked. We know that this specimen is 500 million years old because it has trilobites in it, linking it to the Paleozoic Era, which lasted from about 570 million years ago to about 240 million years ago. This particular species of trilobite lived about 500 million years ago."

Jasper raised his hand again, and the tour guide blinked at him again. "Yes?"

."How do we know that trilobites lived 500 million years ago?"

The woman looked at my friend as if she just couldn't conceive of anyone being so ignorant. "Young man," she said in the voice that adults use when speaking to toddlers and very young children, "we know the trilobites are 500 million years old because they were found in Paleozoic rock, which is 500 million years old."

"So you know that the rock is 500 million years old because it contains trilobites," Jasper said, "and you know that the trilobites are 500 million years old because they are found in a rock that is 500 million years old."

The tour guide beamed, encouraged that he was catching on so quickly. "Right!" she smiled.

But Jasper shook his head. "That doesn't prove anything!" he argued. "That type of argument is called 'circular reasoning,' and you could use it to prove anything you wanted. With that line of reasoning, I could prove that you are 500 million years old!"

By now, the kids were all gathered around Jasper and the guide, listening in on the discussion. They all laughed at Jasper's comment. Miss Wiggins heard the laughter and bustled over to where we were. The guide promptly turned her back on Jasper and walked to the next display.

As our class followed the guide to the next room, we saw a whole row of strange, hairy

creatures, some resembling apes, some looking more like men, and most kind of in between. At the base of each life-size character was a bronze plaque. I pushed through the crowd to read the plaques, and saw names like *Homo habilus, Homo erectus,* etc.

"Look!" said a voice that sounded suspiciously like Tommy's. "There's Mr. Murphy!" The kids laughed, and Miss Wiggins spun around and glared at us. Suddenly, we all put on our most innocent expression. I think she knew who made the comment, but for some reason she chose not to pursue it.

The tour guide called for our attention. "This, class," she said, "may be the most important part of your tour today. You see before you representatives from your family tree. Believe it or not, these gentlemen are your ancestors. Do you see any family resemblance?" The class laughed. I noticed she had her eye on Jasper as she talked.

"Your teacher informs me that the young gentleman with the glasses—" she indicated Jasper with a nod of her head, "has been asking about transitional forms. I'd like to show you just a few. As you probably already know from your study of biology, man evolved from the lower primates." She glanced again at Jasper, then continued.

"As you also know, the change was gradual, and took tens of thousands, if not hundreds of thousands, of years. This is why we do not witness evolution today, even though the process is still at

work. It is a slow, gradual process. Now, since man evolved from the apes, we, of course, would expect to find 'missing links,' or creatures in the process of the evolution from animal to man. Fortunately, modern science has been able to locate a number of these missing links, as we see displayed before us today."

Jasper raised his hand at this point, and I guess we were all expecting it. The guide recognized him. "Yes, young man?"

"Ma'am," my friend said, "isn't this display just a little out-dated?"

Apparently, the question wasn't the one she had been expecting. Her polite, condescending smile was replaced by a puzzled frown. "What do you mean?" she asked.

Jasper explained. "Most of these 'missing links,' as you call them, have been discredited by modern science. Shouldn't you get some newer ones, that you can use with confidence for a few years, until they are discredited?"

Miss Wiggins stepped in. "Jasper, you're being rude!" she sputtered. "And besides, you don't know what you're talking about!"

The class crowded in closer. Jasper turned to face our teacher. "But I do know, Miss Wiggins," he replied respectfully. "Look. They're still using the Piltdown man, even though he was completely discredited way back in 1955. And there's Nebraska man. I can't believe he's still here! He was—"

58

The tour guide cut in. "What do you know about Nebraska man?"

Jasper turned to her. "Nebraska man was discovered near Snake River, Nebraska, in 1921. He was nearly fifty thousand years old, and was one of the more developed ancestors of modern man. He cut a relatively large figure, with a powerful, muscular body, but a much smaller cranial capacity than modern man."

The woman smiled. "It sounds like you've done your homework!"

He shrugged. "I try to." He looked at her through those thick glasses of his. "Let me ask you something, Miss. When Nebraska man was discovered, what was actually found? How much of his remains were actually exhumed?"

The guide looked confused. "I'm not sure," she stammered. "Part of a skeleton, I guess, and most of a skull and jawbone. I know there was enough to accurately determine just what sort of being he was, and how he lived and hunted."

Jasper shook his head emphatically. "No, ma'am," he said, doing his best to be polite. "When Nebraska man was 'found' and presented to the scientific community, the general public was given the idea that extensive remains had been unearthed. But, there was no skeleton, no skull, and not even a jawbone. The creature known as 'Nebraska man' was built entirely from—" he paused for emphasis and held up a forefinger, "one tooth."

Our classmates were shocked, but Japer turned to them and nodded. "It's true!" he insisted. "Check it out. And it wasn't a tooth from an ape, or a human, or a creature that was half-and-half. It was, get this—a tooth from an extinct pig!"

He waved his hand at the display. "It's been the same with most of these," he said. "The evolutionists who put them together had to have a fantastic imagination, because most of the pieces were missing!" The kids laughed again.

The tour guide strutted over to Miss Wiggins and hissed, "Perhaps your group should finish their tour without a guide! I've had enough!" She gave Jasper a dirty look and stalked off.

We marched back to the bus. Miss Wiggins grabbed Jasper by one skinny elbow and muttered, "I'm shocked at your behavior, Mr. Jones. I've never been so embarrassed and humiliated in all my life!"

He looked up at her with a meek, what-did-I-do expression. "I just told the truth," he said softly. "I had to."

8 – The Sidewinder

The bus ride back to school seemed to take forever. We were all tired, and there was very little talk or horseplay. Miss Wiggins had taken the front seat directly behind the driver, and I think she was asleep. I leaned over the seat in front of me—Jasper was in it—and said to him, "From what I've heard you say the last couple of days, I get the idea that you think that evolution isn't very scientific."

He turned around and faced me. "Oh, no," he said, "it's not! Not by any stretch of the imagination!"

He closed the book he was reading and began to slap the palm of his hand with it. "Scientific investigation is a lot like criminal investigation," he said. "A detective, or a scientist, has to deal with facts. Let me give you an example of what I'm about to say.

"Suppose I decide to investigate the thefts in our classroom, but I enter my investigation with my mind already made up—Brandon is the guilty party. As a detective, I conduct my investigation following three rules. One, I accept only the clues that support my theory. Two, I reject any clues, no matter how valid, that disagree with my theory. Three, I make

up my own clues when necessary to attempt to prove my predetermined conclusion. Now, what kind of detective am I going to make? Will I reach a valid conclusion in my investigation? Of course not!"

He warmed to his subject. "Penny," he said with feeling, "science is the same way! You have to deal with facts, not predetermined ideas and conclusions! The evolutionists, in order to prove their theories, have to play by the three rules I just mentioned. Otherwise, their theories are washed up pretty quickly.

"Take the fossil record, for example. Anyone with the most basic intelligence, when shown that there are no transitional life forms, would quickly come to the conclusion that evolution never took place. But, in spite of the evidence, the evolutionist still insists that it did. Why? Because he's chosen to believe it, even though the theory goes against a vast array of evidence."

I nodded. "OK, I'm with you on the first two rules. I agree that they do reject the evidence that disputes their theories. But—what about number three? They would never make up evidence to support their theories!"

Jasper frowned. "Wouldn't they, Penny? We just saw a whole room full of nonexistent 'evidence.' All the 'missing links' they showed us were products of somebody's imagination! Back to the Nebraska man for a minute. They had one tooth,

OK? Where in the world did they get their data regarding the Nebraska man's height, or his body build, or his cranial capacity? All they had to work with was one tooth, and it wasn't a human tooth, or an ape's! Now, tell me, where did they get all the other information?"

I smiled. "OK, they made it up."

Jasper sat back in his seat. "Penny, the whole point is this—when God's Word tells us that God created this universe, we can trust it completely. We believe it by faith. But at the same time, the creation account is validated by a wealth of scientific evidence. Creationism is far more scientific than evolution could ever hope to be!"

† † †

I was on the back porch that evening peeling carrots for Mom when Jasper rode into the yard on his bike. He had an excited, almost worried, expression on his face, and a copy of our town's weekly newspaper in one hand. The *Willoughby Gazette* only comes out once a week, usually on Wednesday, but sometimes as early as Tuesday or as late as Friday. Jasper dropped his bike in the grass, then scampered up onto the porch and dropped the paper right across my knees. "Look at this!" he exclaimed.

The headline proclaimed, "GOVERNOR BRADLEY TO VISIT WILLOUGHBY NEXT

WEEK." I scanned the article, which told of the upcoming visit by the governor and a number of dignitaries. The paper didn't give any details that we didn't already know, but it did reconfirm the fact that the governor was really coming, and it got us thinking again about the possibility of an assassination attempt.

"Penny, we only have ten more days!" Jasper said. "If only we had a map of his route into town and where his stops will be! I believe I could figure out where the attempt would take place, if only I had access to that info! I asked Chief Ramsey for it, but you can guess what he told me."

We discussed the problem for a few minutes till Mom called, "Penny, where are those carrots?"

"Oops!" I told Jasper, "I gotta get working!"

"See you tomorrow!" he said as he headed toward his bike. "I gotta get working on this thing with the governor's visit!"

That evening at supper, I described for Mom and Dad the chill of horror that swept over me when I viewed the scalping scene, and what Nathan and Tommy had done to change it. Dad laughed till the tears ran down his cheeks. "They really shouldn't have done that," he said, wiping his eyes, "but that is funny! Just be sure that you don't do anything to encourage them." He chuckled again.

The subject turned to evolution as I told them about the other museum exhibits and what Jasper had said. Dad nodded in agreement. "He's right,

you know," he said. "That boy has more intelligence as a sixth-grader than most adults do. It's too bad he's not the one teaching the science courses at your school."

"I saw Mr. Jones at Smedley's market the other day," Mom chimed in, "and he was telling me that Jasper has been asking him technical questions that have him stumped. Imagine! And he's a university professor!"

My parents and I went to the midweek prayer service that evening, but I really didn't hear a thing Pastor Rogers said. My mind was miles away, busy with thoughts of the thefts at school, the things Jasper had said about evolution, and most of all, wondering what was going to happen a week from Saturday when Governor Bradley came to Willoughby.

Brandon was back in school the next day, and, as I expected, the thefts in our classroom started again. Missy Taylor lost a nice pink ice ring. She took it off for just a moment to wash her hands after lunch, and when she returned to her desk, the ring was gone.

"Oh, no!" she wailed to Miss Wiggins. "My grandma gave that to me!"

The teacher just shrugged. "Miss Taylor," she said coldly, "I would think you would learn your lesson. We have a thief in our class. Never leave valuables out."

As I climbed on the bus that afternoon, I spotted Holly Landers, a fifth-grader that goes to our church. "What are you doing on our bus?" I asked her in surprise as I slid into the seat beside her. For some strange reason, the fifth-graders get out of school twenty minutes before the sixth grade, and they ride a separate bus home. I guess our school system has extra tax dollars they have to spend and this is one way of doing it.

Holly looked at me. "I stayed late to help Mr. Ellis with a project," she replied. "So I had to ride this bus." She looked at me with a teasing hint of a smile on her round face. "Whatsa matter," she teased, "are you too good to ride with fifth-graders?"

Jasper passed our seat as he boarded the bus, and he leaned over and said in a low voice, "Get your bike out as soon as you get home. I want you to ride into town with me. We need to check something out." I nodded.

Half an hour later, as we pedaled toward town, he explained our errand to me. "I figured we ought to just ride around town," he said, "and make a list of all the possible places that the governor might stop at on his visit. Then, we can decide which would be the most likely for an assassin to strike."

"How would we do that?" I puffed, trying my best to keep up with him.

"We'll look for a place that would allow a sniper to hide, yet have a clear shot when the

governor gets out of the motorcade limo," he replied. "It also will be a place that would allow the sniper, or snipers, to make a decent getaway. There aren't many places like that in Willoughby."

"Then why would they choose Willoughby as the place to do it?" I questioned.

He shrugged. "We're a small town. Maybe they figure there will be less security. I don't know."

I turned to him as a sudden thought struck me. "Jasper, what if there really isn't going to be any assassination attempt? We're basing this whole thing on a fifteen-second conversation that we overheard! Maybe they weren't even talking about killing the governor."

He nodded. "That's what I'm hoping for," he replied. "But we can't just sit back and take that chance. What if there is an attempt on Governor Bradley's life? The police didn't take us seriously enough to even check it out! The way I figure, it's up to us."

A flashy-looking car sped by us just then, and Jasper and I both turned for a look. The car had a low, sleek profile, and looked something like a cross between a Corvette and a Jaguar. It growled softly as it raced down the road. The driver must have been doing seventy.

"Did you see that?" I breathed. "What a car!"

Jasper nodded. As usual, he knew all about it. "It's made over in Italy," he told me. "They're not produced on an assembly line. Only twenty-five or

thirty are made each year. That car has a powerful, twelve-cylinder engine and can probably beat anything else on the road. It's called a Sidewinder."

As he said the name "Sidewinder," he blinked in surprise, and we both turned and stared at each other. "The Sidewinder!" we said in unison. As we watched, the car slowed down suddenly, then made a sharp left turn at the edge of town. "Come on!" Jasper called out. "Let's follow him!" With me in hot pursuit, he pedaled furiously down the gently sloping curve that led into town. We both braked hard to take the left turn.

"There's no way we can catch him, Jasper!" I shouted. "These aren't motorcycles!" But as we made the turn, we spotted the car about a quarter mile ahead, parked at the curb. With renewed rigor, we raced to catch up.

But when we were still a block and a half away, a tall figure strode out to the car and climbed in, and the car pulled away from the curb. Our pedals flew faster and faster. My breath was coming in ragged gasps, but still I pedaled furiously. The car cruised slowly through town, then stopped for another car turning left. We were going to catch him!

"Hey, Spider-Legs!" My heart sank as Brandon Marshall's bike shot out of a side street, followed closely by Bart and Larry, his two shadows. Brandon swerved in front of Jasper, cutting him off and forcing him to skid to a stop rather than hit a parked pickup truck. I swerved around them and

pedaled for all I was worth, still in hot pursuit of the Sidewinder.

But Bart and Larry were on my trail. They passed me, then swerved toward each other, cutting me off. I realized what they were doing just before it happened, and I was ready. I slammed on my brakes, skidded hard, then swerved nimbly and passed them, again pumping for all I was worth.

But it was no use. They caught me again within half a block. This time they rode on each side of me, grabbed my handlebars, and slowed to a stop.

"Slow down, Freckles!" Bart laughed. "You're gonna have a heart attack riding like that! What's your hurry? Take a little rest!"

"Yeah," Larry chimed in, "you deserve a little break today."

"Let me go!" I screamed at them. The Sidewinder, of course, had disappeared. I felt like crying. Just when we get a clue, Brandon and the goons have to come along and ruin it.

9 – Setting the Trap

Monday morning Jasper followed me to a seat on the bus. I plopped my books down on the seat between us, and my lunch box fell to the floor of the bus with a clatter. Jasper picked it up and placed it carefully beside my stack of books.

"What are we gonna do to catch our classroom thief?" I asked him in a low voice, glancing around to be sure that no one was listening. "You keep insisting that it's Audra, but how do you know? And how are you gonna prove it?"

Jasper glanced around us casually, then handed me a thin object wrapped in a small paper sack. "Today's the day!" he whispered. "We're going to bait the trap!"

I opened the sack and the object slid into my hands. It was a flat, clear plastic case with several U.S. coins in a pretty blue holder. There was a half-dollar, a quarter, a nickel, a dime and a penny. "What's this for?" I asked him, puzzled.

"This is the bait," he said in a conspiratorial whisper. "It's a 1958 proof set, worth over fifty dollars. I want you to show it around at lunch, then put it in your desk before we go out for recess. Make sure that everyone sees it, especially Audra.

And, be sure to mention that it's worth a lot of money. Tell everyone that it belongs to a friend of yours, who loaned it to you. But, keep it hidden in your purse until lunch."

I didn't understand what he was up to, but as I started to open my mouth and ask him a question, he shook his head. "Not on the bus," he whispered. "I'll tell you more about it at recess."

I carried the coin set with me to lunch and made sure that I sat close to Audra in the lunchroom. While we were eating, I pulled the coins from my purse and showed them to Candy. "Look at this," I told her, "these coins are worth over fifty dollars!"

As I handed the coin set to Candy, I glanced over at Audra, and sure enough, we had caught her interest. "Where did you get these?" Candy asked me.

I shrugged, trying to act casual. "They belong to a friend of mine," I answered. "I'm gonna give them back to him tonight."

We passed the proof set around, and most of the class had a look at it. "How do you know they're worth fifty dollars?" Audra asked me, examining the coins when it was her turn. "They don't look valuable to me."

"They are," I assured her. "They're worth over fifty dollars to a collector."

When we got back to the classroom after lunch, I watched Audra out of the corner of my eye. When

I thought she was looking in my direction, I made a big production of taking the proof set from my purse and stashing it in my desk. If she really was the thief, she certainly knew now where to find the coins.

Jasper found me on the playground at recess. "Check your desk when we come back from PE this afternoon," he told me. "If the proof set is gone, tell Miss Wiggins right away in front of the whole class. But, don't mention Audra."

"But, what if she just puts it in Brandon's locker?" I asked.

He shook his head. "She can't. It won't fit through the vents."

"It looks like it would," I argued.

He nodded. "I know. But, I measured it. The case is about a quarter inch too wide to slide through. If she takes it, she'll put it in her locker."

"How will we get it back?" I worried.

But Jasper just smiled. "I have a plan," he told me. "We should be able to prove to Miss Wiggins and Mr. Murphy once and for all that Brandon is innocent and Audra is the guilty one."

"Why are you so interested in proving Brandon's innocence?" I asked. "He's no friend of yours!"

Jasper shrugged. "He's not the thief that everyone takes him for. And if we don't stop Audra, she's going to continue to steal."

That afternoon just before P.E., I reached into my desk just to be sure that the coin set was still there. It wasn't. I was stunned. Nobody had been near my desk, but somehow, the coins were gone. I glanced at Jasper, then raised my hand.

"Yes, Miss Gordon?"

"Miss Wiggins," I said nervously, "I had a 1958 proof set of U.S. coins in my desk, and now they're gone! I had borrowed them from a friend of mine."

"Miss Gordon," came the icy, disinterested reply, "I should think by now that you would know not to leave valuables in your desk. I'm afraid the missing coins are your problem. Class, you are dismissed to your physical education class."

As our class returned from P.E., Jasper caught up to me and whispered, "It's time to spring the trap! Listen carefully. Your combination lock looks just like Audra's. Take your lock off your locker and give it to me. But do it casually, and try to make sure that no one notices."

I stared at him. "What are you gonna do?"

He just shook his head. "Wait and see. There isn't time to explain. Now, after you give me the lock, I need you to distract Audra for just a second or two."

I frowned. "What should I do?"

He shrugged. "Anything. Ask her a question; show her something, I don't care. Just get her

73

attention for about two or three seconds. Think you can do it?"

It was my turn to shrug. "I'll try."

When we reached the hallway, I hurried to my locker and dialed my combination. Glancing around to make sure that no one was watching, I handed the lock to Jasper, who came sauntering by just then. He slipped it into his pocket.

I walked over to Audra, who had opened her locker and was rummaging through it. Her opened lock hung by its shackle on the locker door. "Hi, Audra," I said, trying to sound as casual as I could, "Do you remember what our social studies assignment was for tomorrow?"

She turned toward me, and out of the corner of my eye I saw Jasper slip up behind her. "We're just supposed to read the next chapter," she answered. "That's all." She turned back to her locker, and Jasper stepped back quickly.

"Yeah, right," I answered. "Thanks." But Audra had her attention on her locker again, and she ignored me.

I walked over to Jasper, who was standing in front of his opened locker. "Sorry I didn't do better," I whispered. "I tried to get her attention, but she acted like she didn't even want to talk to me."

"You did great!" he reassured me in a soft whisper. "I did what I needed to do. Now, what's the combination to your lock?"

I snorted. "What for? And where is my lock?"

"It's hanging on the door of Audra's locker," he whispered. "I'll get it back for you after school. What's the combination?"

"Right 15, left 23, right 8," I answered. "But I still don't understand what you're up to!"

"15-23-8, got it!" he said. "I'm just making sure that the coin set stays in Audra's locker until Mr. Murphy sees it in there," he explained. "I'll tell you more about it later."

I wondered about it all through last period. I still wasn't sure what he was up to. But I was beginning to suspect that he knew exactly what he was doing.

The dismissal bell rang, and our class headed noisily for the door. When I reached the lockers, Jasper slipped up beside me. "Watch," he whispered, nodding in the direction of Audra's locker.

Audra was dialing her combination on the lock. She finished the combination sequence and gave the lock a tug, but it didn't open. She spun the dial several times, then carefully dialed the combination again. "Come on, come on," she sputtered angrily, tugging at the lock.

Jasper turned to me. "Go get Mr. Murphy!" he whispered urgently. "Just tell him that we have caught the thief in our classroom, and we need him right away! Make sure he knows that it's urgent."

He walked over to Audra, who was trying the combination for the fourth time. "Why don't you go

get Miss Wiggins," he suggested to the exasperated girl. "She's good with stuck locks."

I hurried down the hall to the office. My knees were shaking, but I walked boldly up to the counter. Mr. Murphy was talking to Mrs. Perry, the school secretary. I took a deep breath and blurted, "Mr. Murphy, we need you at the sixth grade lockers! It's an emergency!" I turned and scurried from the office before he could ask any questions. I was just hoping he would follow.

I reached the locker area just as Audra arrived with Miss Wiggins. Jasper was waiting in the hallway. I looked over my shoulder, and sure enough, here came Mr. Murphy, looking like he was about to cloud up and rain. He looked from one person to another, then turned to me.

"Young lady," he boomed, "what seems to be the problem?"

Jasper stepped up. "Sir, we believe we have caught the thief in our classroom. One of the stolen items is in her locker right now."

Mr. Murphy looked down at my friend, then glanced at Miss Wiggins. "What's this all about, Miss Wiggins?"

The teacher looked perplexed. "I really don't know, sir," she answered. "Miss Cantrell asked me for assistance, and—"

Jasper cut in. "Sir, the thief is Audra Cantrell. One of the stolen items is in her locker right now."

Audra's face went white, but she turned angrily to face Jasper. "You're crazy!" she said hotly.

"Audra, open your locker," Mr. Murphy ordered. "If you're innocent, it can be proven easily enough."

"I—I can't!" the terrified girl stammered.

"What do you mean, you can't?"

"The lock is stuck, Mr. Murphy," she replied. "It won't open!"

"Open it anyway!" the principal said gruffly.

Audra dialed the combination, and to her surprise, the lock popped open. "It was stuck a few minutes ago!" she insisted.

Mr. Murphy took her by the elbow and firmly pulled her to one side. "Miss Wiggins, would you inspect this locker?" he said. He turned back to Jasper. "What are we looking for, anyway?"

"Penny had my 1958 proof set of coins in her desk today," the boy detective replied. "It belongs to me, but it was stolen from her desk before she could get it back to me. We have reason to believe it's in Audra's locker."

The man faced our teacher again. "Is that right?"

Miss Wiggins nodded. "Miss Gordon did have a coin set at school today," she agreed, "and she did report that it was stolen sometime today. But, there would be no way of knowing that it was in Miss Cantrell's locker."

The principal opened Audra's locker door. "We'll soon find out," he said. "Miss Wiggins, would you do the honors?"

The teacher rummaged through the locker, while Audra bit her lip nervously. Miss Wiggins turned, holding a familiar object in her hand. It was the proof set.

Mr. Murphy took the coin set from Miss Wiggins' hand, then held it out to me. "Is this the item in question?" I nodded, and he turned to confront Audra. "Young lady, how did this get into your locker?"

Audra stared wide-eyed at the coin set, glanced from Miss Wiggins to me to Jasper, and then turned back to Mr. Murphy. "That's not Jasper's," she lied. "It belongs to my uncle. I borrowed it from him for a few days."

Mr. Murphy groaned, but Jasper stepped forward. "What's your uncle's name, Audra?" he asked.

"Uh—Uncle Mike," she stammered. "Mike Cantrell."

"Have you showed these coins to anyone in our class?" Jasper asked her. "Have I seen them before?"

After a moment, the girl shook her head. "This is a different set from the one that Penny had," she answered.

"Then why are my initials on this set?" he asked her. "Mr. Murphy, if you'll move your

thumb, you'll see my initials scratched into the plastic in the lower right corner."

We all bent close to the proof set in Mr. Murphy's hands, and sure enough, scratched into the plastic, were the tiny letters "JJ." The principal turned back to Audra. "How do you explain this?" he asked sternly.

Audra burst into tears. "I'm sorry!" she sobbed. "I really didn't mean to take all this stuff! Brandon didn't do it; I did! I'm sorry, I'm sorry!"

"Her cousin David is in the fifth grade," Jasper told Mr. Murphy. "He was in on it, too. Audra would hide the stolen stuff in her locker, and then David would take it out of her locker and take it home on the early bus. They figured that there was less chance of getting caught if the sixth grade lockers were searched again at dismissal."

Audra was sobbing as Mr. Murphy led her to his office. Jasper and I hurried out to the parking lot, and just barely caught the bus before it pulled out. It had been quite a day.

10 – We Meet the Assassins

I was upstairs in my bedroom working on homework when my walkie-talkie began to beep softly. I hopped off the bed, scrambled over to the dresser, and switched on the walkie-talkie. Jasper had given it to me several days ago with instructions to always keep it nearby, just in case he ever needed to call me.

I squeezed the black talk button and spoke into the microphone. "Penny here. Over."

"Penny, are you free for an hour or so?" Jasper's voice had a note of excitement that told me something was about to happen. He even forgot to say "over" to indicate that he was through speaking.

"I'm just working on homework," I replied, speaking into the walkie-talkie. "What's up? Over."

"Mr. Bender located the Sidewinder for us!" Jasper was almost shouting, and the walkie-talkie distorted his voice. "Can you come over right away? I want to check it out! Over."

Mr. Bender is our mailman. He delivers to all of Willoughby, as well as some of the rural areas. He and Jasper have been good friends since Jasper was a toddler.

"Hang on, I'll ask Mom," I replied. "Be right back. Over." I set the walkie-talkie on the bed and

dashed downstairs. Two minutes later, I was pedaling for Jasper's.

He met me at the end of his driveway. I turned my ten-speed around and followed him back out onto the highway, heading west away from town. "Mr. Bender saw the Sidewinder out back on a little run-down farm just about a mile from here," he told me as we pedaled. "I described the car to him about a week ago, and he's been watching for it ever since. He left a note in our mailbox today."

Five minutes later, we came to a small, seedy-looking piece of property that at one time had been a farm. A small, white farmhouse with peeling paint and a sagging porch stood in the center of a waist-high jungle of grass and weeds. The house leaned at a crazy angle. The big bad wolf from the story of the three little pigs could easily have blown it over with a huff and a puff. Rusting farm machinery rested here and there in the weeds, and a faded red barn stood in the background, half hidden by a tall stand of beech trees. A blue and white realtor's sign near the highway offered the property for sale.

"This is the place," Jasper said, and I started to turn into the rutted gravel driveway. "No!" he cried out, and I swerved sharply, nearly losing my balance, and turned back onto the highway. Another quarter mile down the road, a narrow lane wound its way through a field to disappear into the woods at the bottom of a gentle hill, and I followed Jasper

down it. We hid our bikes at the edge of the woods and hiked up the hill overlooking the old farm.

Jasper had taken a camera and a pair of binoculars from the basket on his bike and hung them around his neck. They both thumped against his thin chest as we walked. At the top of the hill, we crouched in a thicket of young cedars. Jasper surveyed the property through the binoculars.

I spotted the familiar sleek black car behind the barn. It was completely hidden from the road. "Look!" I whispered, "there's the Sidewinder!"

Jasper nodded, with a pleased expression on his face. "This is the place, all right!" He stood up, snapped a couple of pictures, then turned to me. "Come on, let's get closer!"

I hesitated. "What do you want to do that for?"

"We need to get close enough to get the license number of the car," he answered. "And I want to be close enough to get some snapshots of our suspects, if they come out. I don't have a telephoto lens yet."

It didn't sound like a good idea to me, but I followed him down the hill. I noticed that he crouched low as we picked our way through the weeds, so I did the same. We zigzagged down the hill, always keeping a tree or large bush between the house and us. We stopped less than twenty yards from the building, crouching behind a rusty Ford tractor that looked ancient enough to have been used by Abraham Lincoln.

I flinched as he suddenly grabbed my arm, his fingernails digging painfully into the bare flesh. "Look!" he whispered excitedly.

I raised up on one knee, peering toward the house. "What?" I replied. "I don't see anything!"

"No, Penny," he said, pointing, "Up there!"

I glanced up into the bushes over our heads where he had pointed, but I still didn't see anything of interest. "What are you talking about?"

He pointed again. "Right above your head. What a specimen! It's an *Atlades halesus*!"

I wrinkled my nose. "A what?"

"A Great Purple Hairstreak!" He pointed again.

I finally spotted the metallic blue butterfly in the laurel just above me and snorted in disgust. "Don't you ever think of anything except butterflies?"

Jasper handed me the binoculars, and I lifted them to my eyes and tried to get them focused while he took snapshots of the car and the house. I turned the little knob in the middle of the binoculars, and suddenly the house leaped into focus. It looked like the side door was only three feet away. The door suddenly opened, and I let out a little gasp of fright and took a quick step backwards.

A man appeared in the doorway—a tall, thin man with long, stringy hair, olive skin, and an earring in one ear. He took a drag on the cigarette in his left hand, and as he lifted the cigarette to his mouth, I noticed that his fingernails were long and

manicured. The binoculars brought you that close. Just looking at him gave me the creeps.

A woman was close behind him. She closed the door and locked it, then turned and started down the rickety wooden steps. I knew instantly that she was the hard-voiced woman we had heard on the walkie-talkies just over a week ago. She was big and strong looking, with straight hips and broad shoulders. Her blond hair was cut real short, and she was wearing blue jeans, a man's shirt, and a black leather vest. If the binoculars hadn't helped me see her face, I would have thought she was a man.

"Get down!" Jasper hissed, and I ducked my head behind the tractor, banging my chin on a metal thing that stuck out from the engine. It hurt badly, but at least I remembered not to cry out.

The man and woman walked right toward our hiding place behind the tractor, and Jasper and I quietly melted into the grass. I peered around the huge back tire of the tractor just in time to see the woman drop her sunglasses in the driveway no more than ten feet from where I crouched. As she bent over to retrieve them, her vest hung loosely from her body, and I caught a glimpse of a huge handgun hanging in a shoulder holster.

I don't mind telling you that I was scared. I shrank down as low as I could in the weeds, hoping fervently that she hadn't seen me. But she picked up the glasses and hurried to catch up with her partner, who had already disappeared behind the barn.

Seconds later we heard the rumble of a car engine, and the Sidewinder cruised past our hiding place and pulled onto the highway. Jasper managed to snap one picture of the car as it flashed past.

"Stay here, Penny," he whispered. "I'll be right back." He crawled to the edge of the thick grass bordering the driveway, glanced around to make sure that the coast was clear, then sprinted across to the house. He dived into the lilacs at the corner of the house and disappeared from view.

I waited nervously for him to reappear. Even though both occupants of the house had left in the Sidewinder, I knew that there could be a third person involved. My friend was taking an awful chance.

I scooted through the weeds until I could see the front of the farmhouse. Suddenly, Jasper's head popped up from the bushes below the window. Holding his hands at the sides of his face to block out the light, he pressed his nose against the glass, peering into the window for several seconds. Then his head disappeared into the bushes as quickly as it had appeared. The bushes below the far window began to weave and shake, then Jasper appeared and repeated his earlier performance. I crawled back to the tractor and waited in nervous silence for several minutes.

I stifled a scream as he suddenly plopped his body in the grass beside me. He had come up from

behind, and I hadn't heard him approaching. "What did you see?" I asked.

He shook his head. "Nothing. Penny, there's not a stick of furniture in the house! One room had two sleeping bags spread out on the floor. The closet in that room had a pile of clothes on the floor. But other than that, the house is empty!"

I frowned. "Then how do they live here?"

He shrugged. "Apparently they're just camping out here. This house is their base of operations while they prepare for the assassination, but after Saturday, it's my guess that the place will be deserted."

He rose to a half-crouch and began to retrace our path through the weeds. I followed him, glad that we were finally leaving. The place gave me the creeps. But instead of heading up the hill, we turned and made our way to the barn. I waited in the weeds while he scouted all around the outside of the building.

"Well, there's no need to check inside the barn," he said as he approached me. "No one's been in there for at least a couple of years."

"How do you know that?" I questioned.

"The side door was nailed shut and painted over the last time the barn was painted," he answered, "and that was years ago. And dirt daubers have built nests right across the joints of the big double doors in the front. They're at least two years

old, and they haven't been disturbed. So I know that nobody's been in the barn for at least two years."

We hiked back up the hill. "I'll check out the car registration," Jasper said, "and also see if the realtor can tell us who's renting the house. But, I'll bet you anything they're both under assumed names!"

I frowned. "What makes you think that?'

"Penny," he said, "did you see the sidearm the woman was wearing? It's a French-made machine pistol, capable of firing four rounds per second. The average person has never even seen one of them! These people are professionals! Once the job is finished, you can be sure that there will be no trail left for the police to follow!"

"Shouldn't we go back to Chief Ramsey," I suggested, "and tell him what we've found out?"

"And have him chase us out again?" Jasper said bitterly. "Chief isn't going to listen to us, any more than he did last time. And, these people haven't committed any crime yet, as far as we know."

He picked up his bike from the grass and wheeled it into the narrow lane. "Penny," he said, "I'm afraid at this point it's still up to us. Let's plan to stake this place out again tomorrow."

That night, I had nightmares about the tall, sinister woman with the deadly French-made machine pistol.

11 – Our Stakeout

Jasper met me at the bus stop the next morning with a report on the car and the house. "The car's plates are registered to a Tony Peretti," he told me, "a resident of New York. But get this—the registration is for a 1978 Volkswagen, not a new Sidewinder!"

"How did you find that out?" I asked.

He looked a trifle embarrassed, as if I had asked a question that I shouldn't have. "I can access the Department of Motor Vehicle files through my computer," he finally told me. "But, don't tell anyone, OK?"

"I also called the realtor that has the farm listed. A Mrs. Alva Berryhill, a resident of Spencerville, owns the property. I talked with her last night. She rented the place three weeks ago to a Mr. and Mrs. Paul Smith. They have an option to buy. Mr. Smith supposedly is a bricklayer."

I looked at him in surprise. "You sound skeptical."

He snorted. "A bricklayer? Penny, did you see his hands? No bricklayer in the world has smooth skin and manicured fingernails! And I can guarantee you—his name is not Paul Smith!"

"Then what is it?"

Jasper shook his head. "I don't know yet. But I plan to find out."

"Tomorrow's Tuesday," I pointed out with a grin. "You can do a little investigation on them, via their trash can."

He shook his head. "No good, Penny," he replied. "The city doesn't pick up that far out of town. They burn their trash."

"How do you know?"

"Didn't you see the big 55–gallon drum standing behind the barn? What did you think that was for?"

"I guess I just didn't notice it."

"Didn't notice it? Penny, we walked right by it! How are you ever going to be a detective if you overlook obvious details such as that?"

"Who said I wanted to be a detective?" I snapped.

He lowered his voice. "I'm sorry, Penny. I wasn't trying to put you down. But the trash can method of investigation just won't work with folks who burn their trash."

The school bus braked to a stop just then, and we scrambled aboard. "I just wish we could get a copy of the governor's schedule for Saturday, complete with the planned route for the motorcade. We still have no idea where these people plan to strike."

"How about if I call the governor's office and pretend to be Chief Ramsey's secretary?" I suggested. "They might agree to send it to us."

He shook his head. "Penny, that would be deceitful. It's never right to do wrong to get a chance to do right."

We biked out to the farm again that afternoon after school. We had the walkie-talkies with us so we could communicate if we were separated. Several minutes after parking the bikes in the grass on the far side of the hill, we were crouched behind the old tractor. The Sidewinder was in its usual place behind the barn, so we figured someone must be home.

"Let's split up," Jasper suddenly suggested. "I'll stay here, and you slip back on the ridge behind the barn."

"What for?" I asked.

"We'll be able to see most of the property from those two vantage points," he replied. "I can see the driveway and the side door from here, and you'll be able to see the back door and the car from your station. If either of us spots anything, we can alert the other on the set."

I crawled quietly around to the woods behind the barn, then climbed a short, thick tree with dense foliage. I could see the back door of the house from where I crouched, as well as the magnificent Sidewinder behind the barn, but I would be hard to

spot from down below. I was thankful that I had thought to wear green culottes and a green blouse.

I clicked on the walkie-talkie, and then pressed the alert button to beep Jasper's set. "Agent 008 to 009," I said into the microphone. "Come in, 009. Over."

"OK, 008," Jasper's voice replied. "Anything to report? Over."

"Negative, 009," I answered. "All's quiet back here. I just wanted to make sure I could reach you. Over."

"Leave your set on if you want to," he suggested. "I'll do the same. Just make sure your squelch control is turned way down, so there's no static to give away your presence. Over and out."

I sat back in the tree and surveyed the portion of the property that I could see. Sure enough, there was the big black burning barrel behind the barn, just where Jasper had said it was. It was less than forty feet from the Sidewinder.

The back door of the house suddenly opened, and I snapped to attention. "Jasper, someone's coming out!"

Jasper's voice crackled out of the walkie-talkie. "Who is it?"

I held my talk button down. "It's the woman," I answered. "Looks like she's got a couple of bags of groceries."

"Groceries?"

"Yeah. She's got a couple of big brown sacks, like you get at Smedley's. She's coming out toward the car."

"Let me know what she does," he instructed. "But keep your voice down."

I was trembling with fear and excitement as the woman walked around the end of the barn with the sacks. Suddenly, I realized what she was doing. "Jasper," I called softly. "She put the sacks in the garbage barrel. She's just burning the trash!"

The answer on the walkie-talkie was kind of a strangled yelp. "Burning the trash?" Jasper sputtered. "Penny, I'm coming over to where you are! What's she doing now? Over."

"She's got a lighter," I answered, "and she's setting fire to the edge of one of the paper sacks. Now she's walking around the end of the barn toward the house. Over."

At that instant the bushes behind the Sidewinder parted suddenly, and Jasper came dashing out into the open. One bag of trash was now burning fiercely, and the second was just starting to catch fire. The boy detective raced past the barrel, snatching the second bag out of the barrel as he passed. He paused just long enough to slap the burning top of the paper sack with his bare hand several times to extinguish the flames, then sprinted into the woods just below my tree.

I called him on the radio. "Nice save," I congratulated him. "But what did you do that for?"

He held his walkie-talkie to his mouth, then glanced up and saw my freckled face grinning at him from my leafy perch. "Just trying to save some evidence," he whispered loudly. "Might be some good clues in here."

I glanced toward the house. "Hey, they're coming!" I whispered urgently. "Both of them!"

He immediately scampered behind my tree and knelt behind the trunk, still clutching the precious sack of trash. Our suspects came around the corner of the barn. The man carried two rifles, and the woman had a dark-colored blanket draped over one arm. She opened the car and spread the blanket in the little space behind the seats, and the man carefully placed the rifles on the blanket. He folded the blanket back over the weapons and flipped the seats back into position, and you never would have guessed the guns were there. The suspects climbed into the car with the woman in the driver's seat, and the powerful car rumbled softly as it backed around the end of the barn.

"Did you see that?" Jasper called to me when the car was gone. "Two high-powered rifles, complete with sniper's scopes and silencers! Penny, there's no doubt now! These are the people who are planning to kill the governor!"

I shinnied down out of the tree. "What do we do now?"

"First, we check this trash for clues," the young detective replied. "Then, we head straight for Chief Ramsey's office! He's got to believe us now!"

12 – The Missing Clue

We spread the trash on the ground in the woods on the far side of the hill. I started to dump the sack out on the ground, but Jasper stopped me. He showed me how to spread the trash in layers in the same order that it came out of the bag. "That way, you can tell which items were placed in the bag first," he explained. "Sometimes that can be crucial to an investigation."

We sorted through the trash, but most of it was just kitchen garbage. You know—milk cartons, bread wrappers, and so forth. Jasper immediately stuffed those things back in the sack. He sorted through the other stuff, and finally, the only thing he saved was a letter addressed to Mrs. Paul Smith. When he opened the envelope, we both saw that the top of the letter had been cut away.

"Look at this," he said, holding the letter and the envelope side by side. "The person who wrote the letter is not the same person who addressed the envelope. The handwriting is much different."

I compared the handwriting on the two items, and sure enough, he was right. The letter was written in a small, cramped hand, while the envelope was addressed in a bold, flowing script.

"Why are they different?" I asked. "And why is there no heading on the letter?"

"This letter has been 'laundered' so it cannot be traced," the boy detective replied. "I believe that 'Mrs. Paul Smith' is a member of a large, efficient terrorist organization. Her mail is sent to a 'safe' post office box, which is rented by the organization. When correspondence is received through the box, all addresses and traceable information are removed, and then the letter is forwarded to her. That way, no one can trace the mail to her or back to the writer."

He quickly scanned the letter, stuck it back in the envelope, and then stuffed it in his shirt pocket. "I'll go over it later," he said, "but I doubt if there'll be any clues. These people are professionals. They're being mighty careful. Their only mistake was not destroying this letter immediately."

Jasper slipped down the hill and tossed the rest of the trash back into the can. The flames leaped up again as the sack caught fire. We hiked back to the bikes and pedaled toward town.

We rode down to the police station, intending to try one last time to convince Chief Ramsey that something serious was about to take place. But as we passed the drug store, Jasper braked hard and skidded to a sudden stop. By the time I got my bike turned around and went back, he was off his ten-speed, kneeling in front of a newspaper machine.

"Look at this, Penny!" he exulted. "Just the clue we've been looking for all this time!"

I parked my bike beside his. The *Willoughby Gazette* was out a day early. The headline proclaimed, "GOVERNOR BRADLEY TO OPEN NEW WILLOUGHBY LIBRARY." Jasper popped two quarters into the machine and soon was reading the entire article.

"Listen to this, Penny!" he exclaimed. He began reading the article aloud to me. "Governor Bradley will cut the ribbon Saturday on the new facility of the Willoughby Memorial Public Library as part of his campaign stop in Willoughby. The grand opening of the new 4,000 square foot facility was originally scheduled for early October, but Mayor Thompson has called for the earlier opening to allow the chief executive of state government to take part in the ceremonies.

"This is Governor Bradley's first visit to Willoughby since the beginning of his term as governor, and extensive preparations are being made for the occasion."

The article continued, but he lowered the paper and gazed at me with eyes sparkling with excitement. "This is it!" he exclaimed again. "The clue we were looking for!"

I frowned. "What's so important about the new library? We're talking about somebody trying to kill the governor!"

"Now we know where they're going to do it!" he replied.

"In the new library?"

"No! Just outside the new library! The old steel mill across the street is scheduled for demolition next year. That would be the perfect place for the ambush to take place! The mill would afford the snipers an excellent hiding place with a clear shot at the governor from the fourth floor or from the roof. And the back entrance leads to Tranquil Valley, which would be the ideal escape route. Let's ride out there tomorrow after school. You'll see what I mean."

The next day I could hardly sit still in class. Miss Wiggins called me down twice for not paying attention, and Coach made me sit out the last half of P.E. for the same reason. But I couldn't help it. My head was buzzing with ideas about the upcoming visit of Governor Bradley, and the assassination attempt that was about to take place. In my imagination, I could still see the man and woman who were going to try such an evil deed, and the wicked-looking rifles they were planning to use. I was scared just thinking about it. If the police didn't believe us, what could two kids do to stop such a tragedy?

Finally, the dismissal bell rang, and we headed for the bus. I caught up with Jasper as he climbed aboard. "Still planning to head out to the new library this afternoon?" I asked.

He nodded. "Soon as we get home. Can you come?"

"I asked this morning. Mom says I can go, but I have to be home at five. We have church tonight, you know."

He nodded again as he slid into a seat. "Bike out to my place as fast as you can. Bring your walkie-talkie. I'll be waiting for you."

I glanced at my watch as I turned into Jasper's driveway. Three-thirty. Good. We had an hour and a half. Jasper was waiting, and we lost no time pedaling toward the new library building on the north end of town.

When we reached the new library, there were construction trucks parked along the street, and a number of men were busily working. The new building was beautiful. It was built of a really pretty light-colored brick with lots of gleaming steel and glass. Two flights of marble steps led up to the front entrance, and there was a huge, funny-looking sculpture made of stainless steel beside the front door. Some guy got paid thousands of dollars to design it, and I could have done a lot better than he did. The sculpture was actually a fountain, but of course, the water wasn't turned on yet. We parked our bikes and ran up the stairs to a spot where we could see through the big glass front doors and watch the men laying the new ceramic tile floor. But a construction worker hollered at us to get out of the way, and we had to leave.

"It doesn't look like they're gonna be ready for Saturday," I observed. "How will they get all the books across in time?"

"They won't." Jasper shook his head. "The grand opening Saturday is just a formality, since the governor will be here. But the new library won't actually open until some time in October."

"What will they do with the old library?" I asked, glancing over at the old, white, two-story wooden building less than forty feet away.

"It's been condemned," my friend answered. "They have to tear it down. That's why they're building the new one."

He pointed across the street. "That's where we're heading," he said. "We need to check out the old mill. If my theory is correct, the attempt will take place from right there."

I looked up at the old brick building. A chilling sensation of terror swept over me. I can't explain why, but somehow the old steel mill just looked sinister. To me, the tall building said "DANGER."

We parked our bikes in front of the old library, then sauntered casually across the street toward the old mill. "Try not to look conspicuous," Jasper said. "We don't want to get run out of here, too."

A tall chain link fence skirted the entire property with two strands of barbed wire along the top. The building was enormous, four stories high and nearly a block long. There was a huge parking lot in back that must have covered ten acres. The

property was situated right at the edge of Eagle Mountain, which rose steeply from the edge of the parking lot. A steep, narrow gravel road led from the back gate of the parking lot into the rugged hills surrounding Eagle Mountain, twisting and winding as it climbed.

We followed the chain link fence and hiked around the perimeter of the mill property. "This facility used to employ nearly six hundred workers," Jasper told me. "When they shut it down about fifteen years ago, it nearly killed Willoughby's economy."

We reached the back gate, and Jasper suddenly let out a low whistle. "Look at this lock, Penny," he said. "We're onto something for sure."

I looked at the sturdy brass padlock hanging from the gate and shrugged. I had no idea what he was so excited about. A lock is a lock.

"Don't you see?" he asked, sensing my confusion. "The lock on the front gate was old and rusty. It looked like it's been there for ten or fifteen years. This one's brand new. I don't think it's been here for a week. What does that tell you?"

I shrugged. "They had to get a new lock."

He frowned. "Maybe. But I don't think so. I think our two friends changed it recently, so that they will have quick access to the mill." He looked up the hill. "Let's follow the road a ways. I want to check it out."

I followed him up the steep gravel lane. He stopped to examine some tire tracks at the edge of the road, pulled a tape measure from his pocket and made some measurements, then began walking again without any explanation to me. I was dying with curiosity, but I held my tongue.

"This road leads out into Tranquil Valley," he told me. "The highway is about four miles from here. This would be the perfect getaway spot if you committed a crime."

I looked at him. "Why?"

"Well," he explained, "let's say that our two friends take a shot at the governor from the mill building. They exit through the back gate, which is hidden from view of the street, then drive over the hill and into the valley. At that point, there are at least five different routes they can take.

"When the police follow, they have to come through the mill parking lot since it is the only entrance to this end of the valley. But, both gates are locked and they lose several minutes breaking through them. If they go around by the highway, they travel eight to nine miles farther than cutting through the mill property. Either way, they're five to ten minutes behind the assassins."

A second road cut off to the right and climbed steeply into the woods. I pointed to it. "Where does that go?"

He laughed. "To the mill dump."

"The dump?"

102

"They used the top of that hill for a dumping grounds for years, until the city made them stop. There are huge mounds of slag from the coke furnaces, thousands of old tires from their trucks and equipment, stuff like that."

"How come you know so much about this place?" I asked.

"Dad and I used to hunt rabbits out here," he told me. "When we were looking for the ideal assassination spot, I should have thought of the mill right away."

We passed the turnoff to the second road and continued up the hill. I noticed a rope hanging from a tree at the side of the road, the knotted end dangling about shoulder high. I reached up to give it a tug.

"No!" The word exploded from my friend. He leaped forward and struck my arm, knocking my outstretched hand away from the rope. The crook of my arm stung from the force of the blow. "Penny, don't touch it! It's a trap!" He pulled me back several steps.

"What are you talking about?" I snapped. "You nearly broke my arm!" I gingerly rubbed the inside of my elbow.

He pointed upward. "They've booby-trapped the road! Look!"

I glanced up into the trees hanging over the road, and gasped in horror at what I saw. Most of the branches had been cut from a large tree nearly

two feet thick. The trunk of the tree had been cut completely through with a chain saw, and it was now resting against a six-inch-thick log supported by two other trees. The rope that I had nearly pulled was fastened to a cleverly designed tripping mechanism, which would release the horizontal log. If I had pulled on the rope, the big tree would have come crashing down upon us.

I let out my breath slowly. "Thanks for stopping me in time," I said weakly. "I do believe you saved my life!"

Jasper grinned. "I had to do it," he laughed. "I was standing right beside you, and the log would have flattened me, too." I stuck my tongue out at him.

We moved back to a safer spot and studied the booby trap from a distance. "This confirms my theory," Jasper said with a note of satisfaction in his voice. "This is the place where the attempt will take place."

"Why did they build the trap in this place?" I asked. "The governor's car won't come up here!"

He shook his head. "That's not what it's for. This trap is to buy the assassins a little more time for their getaway."

I wrinkled my nose. "I still don't understand."

"Penny," he said patiently, "this is a roadblock to stop the police from following the getaway car. After the assassins have made their attempt on the governor's life, they will leave the mill and drive

out through this back road. When their car passes this point, they stop for just an instant and drop the tree. Presto! This end of the valley is sealed off from pursuit! It would take a bulldozer to move that tree."

I was amazed. "They've thought of everything, haven't they?"

Jasper nodded. "Yes, but this booby trap was their biggest mistake." He grinned suddenly. "You and I are going to use it against them!"

13 – Dangerous Mission

We stood at the bottom of the fence, staring up at the twisty strands of barbed wire that ran along the top. "How are we ever going to get inside?" I groaned. "This fence must be ten feet tall!"

Jasper glanced up and down the long fence. "Stay here," he said. "I'll be back in a couple of minutes."

As he hiked along the edge of the fence, I sat in the shade at the edge of the woods, studying the backside of the old mill building. Even from a distance, it still looked sinister. Concrete ramps for the loading docks ran along one end of the building. I noticed that there was a huge locked gate at one end of the parking lot with train tracks running under the gate. The tracks led right into a garage door like the one on our house, except it was bigger. The door must have been twenty feet tall. Apparently the railroad cars could go right into the building.

A narrow, black fire escape ladder ran up the back wall to the top of the building, and, just a few feet from it on the side of the building, there was a square, dark opening with no door. Some kind of conveyor belt stuck out of the opening for about ten

feet, ending right above the one forgotten gondola car that sat rusting on the tracks.

Jasper suddenly reappeared. "Come on," he coaxed me. "I've found a way in!" He led me to a place where rainwater draining off the hillside had eroded a four-inch gap beneath the fence.

I drew back. "We can't fit under there!"

"Sure we can!" he encouraged. "I'll lift the fence for you, and you can do it for me."

He gripped the bottom of the fence with both hands and pulled up with all his might, increasing the space under the fence to about nine inches. I lay on my back and scooted under, then lifted the fence for him. We were inside.

We hurried across the parking lot, feeling about as conspicuous as an ant on a dinner plate. I was glad when we reached the edge of the building. I tried the first door we came to, but Jasper shook his head. "They'll be locked, Penny," he said.

"Then how do we get in?" I asked.

He lifted his shirt and unwound a length of blue nylon rope from around his waist. "We'll go in through that conveyor port," he answered.

"Jasper, you're crazy!" I shot back. "If you think I'm gonna climb a rope up the side of that building—and besides, you have no way of even getting the rope up there."

He shook his head. "It'll work," he said quietly. "Watch."

He knotted three knots about a foot apart in the center of the rope. He picked up a flat piece of rusty iron from the ground, passed the end of the line through a hole in one end of the iron, then knotted the rope securely. While I watched nervously, he climbed the fire escape ladder until he was nearly up to the roof.

"Careful, Jasper," I called. "It's a long way down to the ground!"

Holding tightly to a rung of the ladder with his left hand, he began to swing the iron weight at the end of the line. Back and forth the pendulum swung in an ever-widening arc. As the weight reached the end of its arc on the seventh or eighth swing, he suddenly let the line slide through his fingers, and the piece of iron shot out and struck the horizontal I-beam sticking out over the doorway of the conveyor belt. The weight bounced off the beam, fell to the end of the rope, then swung wildly in a circle.

Crooking one arm around a ladder rung, Jasper retrieved the line hand over hand. He swung the weight again, then made another cast. He missed again. On the third try, the weight sailed over the beam. Jasper pulled on the line until the weight caught and held fast. He jerked on the line, but it didn't budge.

And then, to my amazement, he let go of the ladder, gripped the rope in both hands, then swung across and landed on the conveyor as gracefully as a

trapeze artist! Grinning triumphantly, he turned to me. "Your turn, Penny!"

I looked up at him. "No way!"

"Come on!" he coaxed. "It's easy!"

I hesitated. It had looked simple when he did it. And I knew that he wasn't very athletic, even if he was a boy. I shrugged, then slowly began to climb the ladder.

My knees were trembling uncontrollably and my breath was coming in short gasps when he finally called to me to stop. "That's high enough, Penny. I'll swing the rope to you. Try to catch it on the first swing, but be sure to keep one hand on the ladder."

"How about if I keep both hands on the ladder," I stammered through chattering teeth. "I'm scared!" I glanced down at the ground and stiffened with fear. It was a long way down to the asphalt.

"You can make it!" he encouraged. "I'll catch you on the swing. Ready? Here comes!"

He had knotted the end of the rope into a monkey fist. Suddenly, the rope was swinging through the air toward me. I leaned out on the ladder as far as I dared, clutching at the air with my free hand. And believe it or not, I caught the rope on the first swing!

"Great!" my companion called. "Now, wrap both hands around a knot, lean back, then swing across with all your weight. I'll catch you."

I sucked in a deep breath, leaned back, then let go of the ladder and grabbed the rope with my left hand. I kicked free of the ladder and swung across empty space in a long, breathtaking arc.

When I reached the conveyor where Jasper stood, I kicked my right foot up onto the conveyor, scraped desperately for a grip with my left heel, then lost my balance and fell backwards in a long, slow swing back toward the ladder.

I screamed. I was dangling at the end of a rope some thirty feet above the pavement. If my hands slipped from the rope, the resulting fall would probably break both my legs. I've never been so scared in all my life.

14 – Inside the Old Mill

My body trembled from the strain of hanging onto the knot in the rope, and my heart pounded with fear as I dangled precariously some thirty feet above the parking lot of the old steel mill. The rope was still swinging, though the distance lessened with each swing. One moment I was over the end of the empty gondola car, the next over the asphalt parking lot. I realized that no matter where I hit, I was going to be seriously hurt if I fell.

My hands were cramping and my shoulders felt as if my arms were being torn from their sockets. "Help me, Jasper!" I screamed. "I can't hold on much longer!"

"Swing to me, Penny!" he called. "I'll catch you and pull you up on the conveyor!"

"I—I can't!" I wailed.

"Sure, you can!" He encouraged. "Pump your legs back and forth! Get the rope swinging in my direction!"

"How?" I cried. "I can't do it! My hands are beginning to slip!"

"Penny, listen! Swing your feet back and forth! Pump like we used to do standing up on the swings at school! You can do it!"

I grabbed a deep breath and flipped my legs to one side. The rope responded by swinging me slightly closer to Jasper. As I swung back, I flipped my legs in the opposite direction, and my momentum increased. On the return swing, I pumped even harder, and I swung even closer to the conveyor. It was working. If I could just hold on long enough, I could make it to the conveyor. My arms ached from the strain.

On the fifth or sixth swing, Jasper was able to grab my belt with his left hand. His right hand gripping the boom that extended out over the conveyor, he jerked on my belt with all his might. He swung me close enough to enable me to get both feet on the conveyor.

But I was not safe yet. I was totally off balance. My hands were gripping the rope, my feet were on the conveyor, and Jasper was pulling on my belt. But most of my weight was still on the rope, and I was in danger of falling backwards again.

"Aa-r-r-gh!" Jasper suddenly cried out and pulled me onto the conveyor. I was amazed that anyone so small could suddenly have such strength. I grabbed the same steel beam that Jasper held, caught my balance, then slumped to a sitting position on the conveyor, gasping for breath. My arms and shoulders felt all weak and trembled like I had just done about three hundred pushups.

Leaning as far out as he dared, Jasper caught the rope on the return swing and secured it to the beam. He waited patiently while I rested.

"Thanks," I said weakly. "I thought I was a goner!"

He smiled. "I'm glad you're OK! Sorry I keep getting you into such messes!"

When I had recovered sufficiently, we crawled along the conveyor belt through the opening in the wall and found ourselves inside the old mill. It was scary. We were in a huge room, big enough to hold two football fields side by side. The conveyor was about three feet wide, as wide as a sidewalk, but we were about thirty feet above the concrete floor. Down below us were tracks and cranes and huge pieces of machinery. I saw several things that looked like giant, ten-foot sand buckets. Huge boilers and furnaces were everywhere, and big pipes ran in all directions like the legs of a gigantic monster spider. It was an awesome place. That one big room must have taken up about two-thirds of the whole plant.

Jasper pointed to a steel catwalk about ten feet above us that ran the length of the room. "Let's go up there," he suggested. "It'll be a lot safer than this."

We crawled along until we came to a ladder hanging down from the catwalk and reaching to within two feet of our conveyor belt. Jasper scrambled up. Gingerly, I stood to my feet, grasped

the steel rungs, and shakily climbed up to the catwalk. I felt a little safer since the catwalk had sturdy steel railings on both sides.

At the far end of the giant room, the building was divided into four stories. We made our way along the catwalk toward those rooms. "Let's investigate the top story first," Jasper suggested. "I believe that the attack will take place from the roof, or the top story."

"Why?" I asked.

"Because," he answered, "the higher the snipers are, the better their chances of getting a clear shot at the governor. If the governor exits the car on the side closest to the library, which he undoubtedly will, the limousine would shield him if the snipers are on a lower floor."

The first room was securely locked with a huge padlock. Jasper leaned close and scrutinized the lock without touching it. "I'd say it hasn't been disturbed in years," he said. "Let's move on."

The next room was unlocked, with the door standing wide open. Jasper paused outside the doorway and quickly surveyed the room before entering. "Come on," he said finally. "Let's check it out."

The room was empty, except for two ancient file cabinets with all the drawers removed. Thick, blackish-gray dust was everywhere. It must have been an inch thick. Two sets of footprints led into

the room, plainly visible in the dust. Jasper knelt and took measurements.

We peered out through the dusty window, gazing down on Swanson Street four stories below. It was neat to see the new library building from such a height. I glanced over at Jasper, who was busily examining the metal tracks that the window slid on. He pointed out that the window was securely fastened closed by a large carriage bolt through the frame.

"Think this is the place?" I asked. "You can see the library from here."

He shook his head. "The angle isn't the best," he told me. "It'll be better farther down."

Two rooms farther down, we hit pay dirt. The same two pairs of feet that had made tracks in the other rooms had also entered this room, but it was obvious that they had spent more time in this room. Footprints were everywhere, but especially under the windows. Jasper studied the tracks for several minutes before he let me enter the room.

"Careful where you walk," he told me. "We don't want to leave any new footprints. Step only in the tracks that they made."

We glanced out the window and realized that we were now directly across the street from the front door of the library. I gazed at the new building. "Why does this room seem darker than the others?" I mused. "It's almost as if the sun has gone behind a cloud."

Jasper almost shouted. "Look at the window, Penny!" he exclaimed. "Someone has placed one-way reflective film over the glass! And it's brand-new!"

"Why would they do that?" I questioned.

"To keep the people in the street from seeing in the window," he explained. "We can see out, but nobody can see in."

He suddenly pointed. "Look, Penny! The bolt through the window frame has been removed recently! This window can be opened!" He slid the window open just a few inches, then closed it again gently. "What do you know," he commented. "The window track has been lubricated! And recently!"

He turned to me. "This is it!" he exclaimed. "There's no longer any doubt in my mind. This room is where the assassination attempt will take place. We've got to go back to Chief Ramsey!"

At that moment, a door slammed somewhere down below in the mill building. The sound echoed back and forth across the huge room we had crossed on the catwalk a few minutes earlier. We looked at each other in horror. Someone was coming!

15 – Trapped!

"Quick!" Jasper hissed. "We've got to get out of here!" We tiptoed hurriedly to the door, then paused as Jasper peered cautiously around the corner. He drew his head back slowly. "It's them!" he whispered. "The assassins are here!"

He motioned for me to follow. "Let's crawl along the walkway to the northwest corner of the building. If we stay against the wall, they can't see us from the ground floor."

We crawled quickly from the room. The iron walkway was greasy and dirty. I wrinkled my nose in disgust, imagining how black my hands and knees must be getting. It was as if Jasper could read my thoughts. He turned around and whispered over his shoulder, "At least there's not much dust to show our tracks."

As we crawled along the walkway, a door just ahead of us suddenly slammed shut, and I jumped at the sound. The door suddenly reopened, and we both froze where we were. But nobody came out, so we resumed crawling. As we passed the open doorway, we saw the cause of the banging door. Several panes of glass were missing from the windows in that room, and the wind was whistling

through the openings, occasionally blowing the door back and forth.

Suddenly, as we reached the end of the walkway, we heard footsteps on the iron stairs that led up to our floor. Jasper stood up, gripped the edge of a heavy green metal sliding door, and slowly slid it open. I could see it took some effort. "Quick!" he whispered. "In here!"

I blocked the door open with my foot, and he quickly stepped through. The door was spring-loaded, and kept trying to close on my foot. When Jasper was in, I shoved hard against the door, opening it a bit wider, then did my best to block it open with my foot as I went through.

I gasped in surprise. Inside the door, there was no floor, only a dark, empty hole. Jasper was clinging to a vertical pipe bolted against the wall, so I grabbed the bracket that held it to the wall with both hands and held on for dear life. My foot struck against another bracket down below, and I quickly stepped up on it. The door slammed shut with a loud clang when I removed my foot.

Moments later, footsteps paused just outside the door. "What was that?" a man's voice asked softly, and I recognized it immediately as the voice on the walkie-talkies.

"Someone's in here!" a harsh female voice responded, and I knew immediately who that was, too. The would-be assassins were in the hallway, just on the other side of the door. I knew it would be

only a matter of minutes before they found us. My imagination was working overtime. I could picture all sorts of things these ruthless killers would do to us.

"Let's split up," the woman suddenly ordered. "If they're in here, we'll find them! Keep an eye on the entrance at the far end of the building."

There was a window far below us, and my eyes were gradually getting used to the dim light. We were in a tall, vertical shaft, and I could tell that the bottom was quite a ways down. I could make out Jasper's face, and he looked just as scared as I was.

Just then, a door slammed suddenly and the man cursed, then laughed. "There's our intruder," he said. "Just a door banging in the wind!"

Jasper let out a long sigh as we heard the footsteps disappear down the walkway. When we could no longer hear them, we realized that the couple had entered the room with the reflective film on the window.

"What is this place?" I asked Jasper.

"It's a shaft for some kind of an old service elevator," he whispered. "We're hanging onto one of the guides for the elevator car. The cables are just a few feet behind us."

He peered down into the darkness below, then looked back at me. "There's a bracket fastening this thing to the wall about every two feet or so. It'll be like climbing down a ladder with every other rung missing, but I think we can do it! Are you game?"

"Ready when you are!" I responded, trying to hide the fear I felt. I was shaking like a banjo string.

Twenty minutes later, we were riding our bikes down Swanson Street. The little window had opened easily enough, and the eight-foot drop to the ground was nothing. We were just glad to get out of there alive.

"Now for the real test," Jasper said as we pedaled along. "Will Chief Ramsey believe our story?"

I glanced at my watch as we walked in the front door of the Willoughby police station. Five after five. I was late already. Chief Ramsey was at his desk as we walked in, and he clapped a pudgy hand to his forehead when he saw us. Jasper walked straight up to the counter and addressed the law enforcement officer.

"We'd like to talk to you," he said politely. "It's about the assassination attempt on Governor Bradley Saturday."

I thought the chief was going to explode. He rose slowly from his desk, and his face instantly became red with anger. He strode toward the counter, and I unconsciously took a couple of steps backwards. I could tell he was boiling mad.

"You're a bright boy, Jasper Jones," he said slowly, gritting the words through clenched teeth. "But you are not a police detective, and this had better be the end of all this nonsense! Now, get out!"

"Please, sir," Jasper begged, "listen to us! We have some new evidence that you can't afford to ignore! The governor's life is in jeopardy!"

"Your life is going to be in jeopardy if you don't leave, and leave now!" the man growled. "We don't have time for your silly little games! Now, I repeat myself—get out!"

Jasper finally realized that the heavyset officer was not about to listen to anything he had to say. With a deep sigh, he turned to me. "Come on, Penny," he said. "Let's go! Chief Ramsey still doesn't believe us."

"He'll believe you after Saturday!" I said angrily. "But then it will be too late!"

"What can we do?" I wailed as we climbed on our bikes. "Nobody will believe us, and there's nothing we can do to stop the assassination attempt! By the time people find out we are telling the truth, Governor Bradley will be dead!"

"It's up to us now, Penny," he said softly. "I have a plan. It's pretty far-fetched, but I guess it's our only chance now. Be praying that it works!"

16 - Saturday

The fateful Saturday dawned bright and sunny. I was awakened by the steady beep, beep, beep of the walkie-talkie on my dresser. I switched on the unit. "Penny here," I responded. "Over."

"Today's the day, Penny!" Jasper's cheerful voice informed me. "Are you ready? Over."

"As ready as I'll ever be," I answered. "Over."

"The ribbon-cutting ceremony is scheduled for two o'clock," he said. "Can you meet me in front of the old library at one? Bring your walkie-talkie. Over."

"I've got my Saturday chores to do," I told him. "But I'm sure I'll be through long before then. Mom will let me go. Over."

"Call me right back if you have any problem," he replied. "I need you there. Over."

"I still don't see what two kids can do," I told him. "You said yourself that these people are professionals. Over."

"I have a plan, and I'm praying it will work," he said. "I've been praying all evening that it would be sunny today, and the Lord has answered my prayer. Maybe He'll answer this prayer, too. See you at one. Over and out."

I clicked the talk switch on my unit. "See you at one. Over and out."

I whipped through my chores in record time. After the chores were done, the rest of the morning seemed to drag. I guess I looked at the clock every two minutes. One o'clock seemed like it would never come. I was nervous and antsy with that butterflies-in-the-stomach feeling you always get before an important ball game or a piano recital. I ate lunch at eleven-thirty, then left the house just after noon.

I pedaled slowly, but I still reached the library by twelve-twenty. Swanson Street was a busy place. The police had barricaded off the side streets, and there were brown paper bags over the parking meters with "no parking" written on them in black magic marker. Two police cars were there with lights flashing, and a crowd was already forming behind the yellow police ribbon across from the new library.

A microphone was set up at the top of the new library stairs for the governor to use, and two giant speakers were on the front lawn. A wide, red ribbon, ready for Governor Bradley to cut with giant scissors after he finished his speech, stretched across the doorway of the new building.

Fortunately, I could still get into the old library. I padlocked my bike at the rack, then sat down at the curb to wait for Jasper. He arrived at twenty minutes to one. I unlocked my chain, slipped it

through his bike frame, and locked our bikes together.

"This is it, Penny," he said with a serious look on his face. "It's up to us. We can't fail."

He took a flat package from the basket on his bike, and I looked at it curiously. "What's in there?"

He shrugged. "Just a little weapon to try to thwart the assassination attempt. I'll show you later."

We pushed our way through the crowd in front of the steel mill across from the library, then hiked along the fence that surrounded the parking lot in back. "Where are we heading?" I asked.

"We're just going to check and see if our suspects have arrived yet," he answered.

When we reached the corner of the fence, he stopped me. "No! Not along the back fence," he whispered. "If they're watching the parking lot, they'll see us!" We cut through the woods instead.

We circled around behind a little ridge, then crept over the top to a spot where we had a clear view of the parking lot. "There's the Sidewinder!" I whispered excitedly. The exotic black car was parked facing uphill just outside the back gate, ready for a fast getaway.

Jasper nodded. "Just as I thought," he whispered. "They're already here." He looked at me with a strange grin on his face. "Let's go spring their own booby trap on them, shall we?"

We slipped through the woods, hiking parallel to the road, but staying out of sight. I followed Jasper silently, not quite sure what he was up to. We came out on the road just above the booby-trapped tree. He stopped about twenty yards from the trap.

"Stay here," he told me. "This ought to be interesting."

While I watched, he walked down the road, pausing under the booby trap. He reached up, grabbed the hanging rope, and gave it a sharp tug. Then he ran like mad. The horizontal log was released, and as it fell, the big tree followed. The huge tree fell slowly, cutting through the branches of the smaller surrounding trees like a giant knife. With a crash, it slammed into the ground, bounced into the air a foot or two, then lay across the road. It was quite a show.

"Why did you do that?" I asked, as Jasper walked back up toward me.

"Just making sure that they won't have an easy getaway," he replied, laughing. "Come on! Let's go to the second part of my plan."

He glanced behind me, then suddenly froze. "Don't move!" he whispered.

I held perfectly still, my heart pounding with fear. "What is it?" I quavered.

"It's a *Vanessa Atalanta,*" he whispered, his gaze still on whatever it was behind me.

My heart leaped into my throat, and cold chills scrambled up and down my spine. "What?" I squawked.

"A *Vanessa Atalanta,*" he repeated. "Commonly known as a Red Admiral." He crept toward me. "Don't move—it's just above your head."

I lifted my head and saw a big, brown and red butterfly resting on a branch just above us. I let my breath out slowly. "A butterfly!" I sputtered. "I thought it was something important! Thanks a lot!"

Minutes later, we were on the second floor of the old library. I glanced at my watch and was amazed to see that it was already one-thirty. Jasper cranked the window open a few inches, then shut it quickly.

"It works," he said. "Now, Penny, listen carefully. I need you to do two things for me, and they're both vital to the success of our mission to save Governor Bradley. Number one: watch the window in the steel mill. It's the seventh one from the end, top story. When it opens, call me immediately on the walkie-talkie. Just say 'Jasper, it's open.' That's all. I'll leave my unit on the whole time, and you do the same."

"What's the second thing?" I asked suspiciously.

He pulled a string of firecrackers and a disposable lighter from the bag and handed them to me. "Just light these," he said.

I stared at the fireworks, then at him. "You're crazy!" I sputtered. "Man, I'll be in so much trouble—"

He cut me off. "Penny, listen," he said earnestly. He began to separate some of the fuses of the firecrackers from the others. "When you see the governor's motorcade come to a stop, lay three individual firecrackers on the window sill beside the rest of the string. But keep them out of sight until then. Crank the window open and get ready. The instant the governor steps from the car, light the three firecrackers one by one, and throw them as far as you can out the window. Then, light the rest of the string and toss it out. But do it as fast as you can. Don't bother to close the window. When you've tossed the firecrackers, get out of this room as fast as you can. Leave by the back stairs, and go out through the emergency exit."

"But an alarm will sound!" I protested.

He nodded. "I know. But it's the only way. Now, when you're out of the building, head as fast as you can for the road that exits from the back of the mill parking lot. I'll meet you at the point where the second road veers off for the dump. Watch out for the Sidewinder. Whatever you do, don't let them see you!"

"I'm gonna be in a heap of trouble when this is over, you know," I told him.

He nodded. "I know. Unless, of course, it works."

127

"And just what are you gonna be doing this whole time?" I asked.

He pulled a mirror from the bag. "Just trying to make sure the snipers never get a clear shot at the governor," he answered.

I stuffed the firecrackers and the lighter back into the bag, and he walked away. He paused at the door. "Penny," I looked up. "Be praying." I nodded.

I had just looked at my watch—five minutes till two—when Jasper's voice came over the walkie-talkie. "Penny. Let me know the instant that window opens. I can't see it from where I am. Over."

I peered out the window, scanning the growing crowd on the sidewalks. "Where are you? Over."

"I'm hiding in the bushes beside the fountain sculpture," he answered. "They chased me off the library steps. Over and out."

At that moment, an elderly lady came puffing up the stairs. She looked at me suspiciously, so I grabbed a book and pretended to be deeply absorbed in it. She browsed through the shelves for a couple of minutes, then disappeared down the stairs. I dropped the book to the table. The title was *Arthritis and You*.

The crowd outside the library suddenly became very noisy, and I leaned against the glass. Police motorcycles were cruising slowly down the street toward the library followed by a big black limousine with the state seal on the door. I opened

the bag and arranged my firecrackers on the windowsill, then cranked the window open.

Everything happened so fast that it's hard to describe just what did take place. I glanced up at the window of the steel mill just in time to see it slide open a few inches. I grabbed my walkie-talkie. "Jasper, it's open!" I reported. As I set the walkie-talkie down, I leaned toward the window and saw Jasper come dashing down the library steps, the mirror in his hands. He held the mirror over his head, and I saw a flash of sunlight reflected on the side of the brick wall of the old mill. "What on earth?" I thought.

But I had another job to do. The limousine had slowed to a stop right in front of the new library, and the back door opened. But it was the wrong door! The governor was going to get out on the left side, on the side away from the library! In panic, I realized that he was going to be completely exposed to the snipers' gunfire!

A big man climbed from the car. It wasn't the governor, probably a bodyguard, but I lit the first fuse anyway. When I was sure the fuse was burning, I tossed the firecracker out the window. With trembling hands, I lit the other two singles and tossed them, then the entire string.

The first firecracker exploded just as the governor stepped from the car. The timing was perfect. I saw the governor's head and shoulders above the top of the limousine for an instant as he

straightened to a standing position, then he disappeared again as the burly bodyguard shoved him frantically back into the car. The bodyguard leaped in and slammed the door, and tires squealed as the powerful limousine accelerated down the street. The motorcycles roared as the officers gunned them at full throttle.

In the street below, it was Panic City. Women were screaming, men were shouting, and uniformed officers were dashing toward the library with guns drawn.

I had seen enough. I grabbed my walkie-talkie and ran from the room, legs flying as I dashed down the back stairs. I pushed hard on the red bar on the door that said "EMERGENCY EXIT ONLY— ALARM WILL SOUND" and sure enough, an alarm did sound. But the door opened, and I was outside. I dashed around the corner of the building, thankful to be away from the loud, raucous buzzing of the alarm.

I slipped into the midst of the frenzied crowd and made my way across the street. I had no idea whether or not we had been successful. Was Governor Bradley still alive? Suddenly over- whelmed by the tension that was bottled up inside me, I burst into tears. Wiping my eyes with the back of my fists, I hurried behind the mill to meet Jasper.

And then, I saw the Sidewinder. I dropped behind a fallen log just in time. The male suspect was locking the rear gate of the mill parking lot, and

the woman was in the driver's seat, the big engine rumbling. The instant the man jumped in, the powerful car accelerated up the slope in a shower of flying gravel. *They don't know about the tree,* I thought. *Boy, are they in for a surprise!*

I scrambled through the woods toward the point where the road cut off toward the dump. I hid behind a thick clump of brush. When the Sidewinder came back, I wasn't planning to be in sight.

Where was Jasper? Had the police grabbed him? He was out front where the action was, and he had taken more risks than I. Perhaps he had not been able to get away in time.

Suddenly, I heard the roar of the Sidewinder engine, and then the powerful car backed into view. With a shower of flying gravel, the woman braked hard, shifted, then gunned the vehicle into the turn that led up to the mill dump. The rear wheels spun, the back end of the car fishtailed dangerously, and the car accelerated swiftly and disappeared up the hill. I caught just a glimpse of the man as the car flashed past my hiding place, and believe me, he didn't look too happy.

Suddenly, a hand gripped my shoulder, and I screamed my loudest. "Penny!" a voice whispered in my ear. "It's me!" What a relief to find that the hand belonged to Jasper.

"The Sidewinder just went past!" I stammered. "They're heading up to the dump!"

He nodded. "I knew they would," he replied. "Let's head up there for the capture!"

I stared at him. "You're going after them?"

He nodded. "That was part of the plan. Come on, let's hurry!"

For some strange reason, I followed a skinny, unarmed boy up the hill after two desperate, heavily armed criminals. I still can't tell you why I did it.

"Hey, Spider-legs!" a voice suddenly called, and I looked up the hill to see the leering face of Brandon Marshall. I groaned. Of all the times for him to show up!

"Brandon's here!" I told Jasper in disgust.

To my surprise, he just grinned and nodded. "He's part of the plan, too."

And then, I saw Larry on the other side of the road, and Bart in a tree over our heads. What in the world was going on?

The rumble of a powerful engine announced the return of the Sidewinder. I ducked into the bushes, but Jasper called up the hill to Brandon, "Get ready!" When the car came into view, he shouted, "Now!"

Suddenly, fifteen or twenty old truck tires came rolling down the hill toward the Sidewinder, and toward us. I learned later that Friday evening Brandon's gang had spent about three hours helping Jasper set a trap on the hill below the dump. The tires were arranged in rows above the road, held in place by ropes with quick-release knots.

I scrambled for the safety of the hillside above the road, then turned to see what happened. The tires came speeding down the hill. Some of them slammed into trees or bushes, and never even made it to the road. But most of them careened across the road, bounced off the embankment on our side, then landed in a heap back in the middle of the road. Like everything else he does, Jasper had planned it perfectly.

The woman assassin slammed on the brakes just in time, and the Sidewinder skidded to a stop a foot or so from the tires. "Fire two!" Jasper called, and I looked up just in time to see another round of tires come charging down. Again, the second volley was planned perfectly. Most of the second group of tires came to rest in the road behind the car. The mighty Sidewinder was now boxed in.

The doors of the car flew open, and, cursing and screaming at us, the furious occupants climbed from the vehicle. But, they had made a big mistake. They had ignored Jasper's shout of "Broadside!" There was a low rumble on the hillside, and the snapping of twigs and branches as the third group of tires came rolling down.

Jasper and his crew had saved the best for last. There must have been forty or fifty tires in the last volley. With cries of alarm, the assassins scrambled for the safety of their car. They made it just in time. The doors of the Sidewinder slammed shut just an instant before the tires were upon them.

It was funny to watch, but kind of scary at the same time. Some of the tires rolled harmlessly past the car, but many of them slammed into it with tremendous force. I heard the crunching of sheet metal as the heavy tires struck the door, the fenders, the wheels, and bumpers. I groaned as I realized what was happening to that beautiful car. Other tires struck the tires that were bouncing off the car, were catapulted into the air, and actually leaped over the car! They rolled up the other hill a short ways, then returned to batter the driver's side of the vehicle. When it was all over, the low-slung Sidewinder was nearly buried in truck tires! I laughed till my sides hurt.

The occupants couldn't even open the doors because of the tires. The woman stuck her head out the car window and managed to squirm out. I suddenly realized the danger we were still in when I saw the fearsome automatic pistol in her hand.

But Jasper still had another bomb to drop— literally. When the woman stood to her feet outside the car, a missile dropped from the tree overhead, struck her shoulder, and knocked her to the ground. She scrambled to retrieve her gun. Her body was covered in white power. I looked up into the tree just in time to see Bart release his second bomb. Like the first, it was a five-pound bag of flour. Apparently, slits had been cut in the sides of the bag, for when it struck the woman, it also burst open, showering her with flour.

The man wriggled out through the driver's window of the Sidewinder; and as he did, the third flour bomb hit him. He gave up too easily. He just ducked back inside the car and sat still.

I was doubled over with laughter. Here were two professional assassins held at bay by the cunning of an eleven-year-old detective! But suddenly, the laughter died in my throat.

The woman had retrieved her gun, and she came dashing up the hill toward us. Before I could realize what was happening, her strong arm was around my neck in a bone-crushing chokehold, and the muzzle of the deadly automatic pistol was thrust against the side of my head.

"That's enough!" she cried. "Make one more move, any of you, and this little twerp gets it!" I gasped in terror. I knew she was dead serious.

17 - Escape

Cold chills of terror swept over me as the woman tightened her strangle hold around my throat. I thought she was going to break my neck. Her grip was so tight I could hardly breathe. But the sensation that really panicked me was the steady pressure of the machine pistol against the side of my head. If my captor even touched the trigger, I knew what would happen.

But suddenly I had a strange peace. I had received Jesus as my Savior several years before; and now the thought suddenly occurred to me that if the desperate woman who held a loaded weapon to my head did decide to shoot me, I would instantly be with Jesus.

The woman dragged me down into the middle of the road, right behind the ruined Sidewinder. "Come out!" she snarled at my companions. "All of you! I have your little friend, and I won't hesitate to use this gun on her."

Jasper and the others quietly shuffled down from the woods and stood meekly in the road. I noticed that Jasper stepped on one shoelace, then moved his foot sideways, untying his own shoe. *Funny*, I thought to myself.

At that moment, we all heard the sound of police sirens as two Willoughby patrol cars sped up the hill toward us. Their impending arrival didn't seem to bother the woman with the gun. "No problem," she said. I wasn't sure if she was addressing her companion or us. "If they get in our way, the girl dies." Again a surge of fear stabbed at my heart.

Jasper bent down to tie his shoe, then suddenly raised up and threw a large rock into the bushes behind us. "What on earth?" I thought.

A moment later, I winced at the sudden, sharp pain in my arm, then a second stab of pain in the side of my face. The air was filled with insects buzzing angrily. The tremendous pressure around my neck suddenly was gone, and I spun around to find my captor slapping frantically at her face and body, screaming curses as she did. Now I understood. Jasper had tossed his rock into the middle of a nest of hornets!

All seven of us ran like crazy to escape the angry hornets. I know it wasn't planned, but somehow, every one of us headed down hill together in a frenzied group. Maybe it was just because it is easier to run down hill. At any rate, as the first police cruiser rounded the corner, he was nearly run over by our little stampede.

As we came to a sudden stop in front of the police car, I noticed that the deadly machine pistol was now in the hands of Jasper. He pointed the

weapon at the two crooks. "Not another step, Miss Vanetti!" he ordered in as gruff a voice as he could muster.

The officers were Bill and Clark. As they climbed from the patrol car, it was easy to see that neither of them was sure what to do. They had no idea what was going on. "Jasper!" Officer Clark yelled, seeing the weapon in my friend's hands. "Put down that gun!"

"Officer, help!" the woman assassin called. "These young hoodlums have wrecked our car, and now this one is threatening us at gun point!" I noticed several large welts on her face, neck, and arms, and realized with satisfaction that the hornets had gotten her better than they had me. Maybe it was her perfume.

Jasper handed the automatic weapon to Officer Bill. "Officers," he said grandly, "I give you Miss Alexis Vanetti, international terrorist! She and her accomplice are wanted all over Europe. But you'll want to hold them for the attempted murder of Governor Bradley."

"Officer!" the woman insisted again, "these young ruffians are dangerous! Look what they did to our car! Bill Simmons and I are officials with the National Wildlife Federation, and we're in the area to check on reports of pollution in local lakes and streams." As we reached the crumpled Sidewinder in its burial mound of old tires, she flashed open a wallet and displayed an official–looking badge.

My heart sank. Had we been following the wrong suspects? But Jasper didn't hesitate. "Look in the car," he told Officer Bill. "You'll find two high-powered rifles complete with scopes and silencers behind the seat."

The boys cleared the tires from the car while the rest of us watched. When the last of the tires was out of the way, the man suspect helped Officer Bill wrestle the driver's door open. Bill released a small lever near the floor, and the seat popped forward.

We all leaned forward for a glimpse of the rifles, and I groaned inwardly. The space behind the seat was empty. There were no rifles.

Officer Clark addressed the man and woman. "Sorry about the car," he said. "I trust your insurance will cover it. We'll give you a ride back to the station to use the phone."

He gave Jasper and me a hard, cold look. "As for you two, you're gonna have a lot of explaining to do. What you did today is inexcusable."

18 - Sherlock

Jasper rode into the yard and tossed a banded newspaper on the porch. I dropped a handful of green beans back into the kettle on the porch floor and picked it up. When I snapped the rubber band, the paper unrolled to reveal the headline "JUNIOR DETECTIVE FOILS PLOT TO ASSASSINATE GOVERNOR." Under the headline was a picture of Jasper shaking hands with Governor Bradley, while Brandon, Bart, Larry and I looked on. I was amazed. Our pictures were in the paper! And this wasn't the *Willoughby Gazette* either, but one of the big city dailies!

"Read the article," Jasper instructed me.

"An assassination attempt on the life of Governor William Bradley in the little town of Willoughby was foiled Saturday by the shrewd thinking of an eleven-year-old detective," I read. "Jasper Jones and four friends, armed with firecrackers, mirrors, old tires, flour, and hornets, captured two left-wing terrorists armed with high-powered rifles and automatic machine pistols, shortly after an attempt was made on the governor's life in front of the new Willoughby Memorial Public Library.

"Alexis Vanetti, 32, and Muhammad Abdul Chambers, 34, were arrested by Willoughby police and charged with attempted murder, assault with a deadly weapon, kidnapping, and other charges. The pair is being held in custody at an undisclosed location pending formal charges. Miss Vanetti also faces a number of charges of international terrorism."

The article went on to describe Jasper's investigation and our use of firecrackers and mirrors to alert the police and blind the snipers. There was even an interview with Chief Ramsey. "Jasper tried to warn us on three separate occasions," the paper quoted him as saying, "but we viewed him as an irresponsible kid with a wild imagination. In reality, Governor Bradley owes his life to this quick-thinking young detective."

"Listen to this," I told Jasper, reading the conclusion of the article to him. "The shrewd investigation by this talented young man reminds one of the legendary detective, Sir Arthur Conan Doyle's super-sleuth, Sherlock Holmes. But the fictional detective has nothing on the young man who saved the governor's life. Sherlock Jones, the citizens of this entire state owe a great debt to you."

I dropped the paper on the porch. "Wow!" I exclaimed, "he compared you to Sherlock Holmes!"

Jasper just shrugged. "He overdid it a bit," he replied modestly.

141

"Well, I'm glad the whole thing is over," I said with a sigh. "Things got just a bit too freaky for me."

The boy detective shrugged again. "It wasn't that bad!"

"That's easy for you to say!" I flared angrily. "I was the one with the machine pistol held to my head, remember? And I was the one who nearly fell three stories to the asphalt behind the steel mill! And I was—"

Jasper held up his hands to silence me. "OK, OK, OK," he agreed. "There was some danger involved. But, the Lord got us safely through it all."

"Yeah, well it was scary going through it," I responded. "And when it was all over, they were ready to arrest me for throwing the firecrackers! Not to mention wrecking a megabuck sports car! My dad says that we shouldn't have gone after two armed adults like that! We could have gotten killed!"

Jasper looked sheepish. "Your father isn't the only one saying that," he replied. "I heard it from my parents, from Chief Ramsey, and even from Governor Bradley. I guess what I did was pretty dumb."

"It wasn't all your fault! I was in on it, too!"

He nodded, still looking unhappy. "But I was the one who talked you into it, and I should have known better. I'm sorry. I'm not perfect."

I grinned at him. "I wouldn't have missed it for the world. You're forgiven." He looked relieved.

I kicked at the paper. "If you hadn't pointed out the two bullet holes in the governor's limousine, we'd both be in jail!"

A thought suddenly occurred to me, and I snatched up the newspaper and skimmed through the article. "Here it is," I said. "Alexis Vanetti! That's the name you mentioned to Officer Bill just after we escaped from the hornets! How did you know?"

He grinned. "Remember the letter we snatched from the fire?" I nodded. "The Brotherhood, as they called the terrorist organization they were working for, had cleaned up the letter. They removed all addresses, names, etc., so that nothing could be traced."

I nodded again. "You told me about it."

"Well," he continued, "they missed one! The letter was from Miss Vanetti's sister, and she called her 'Alexis' by name. Apparently, the Brotherhood didn't spot it, and they left it in. That was all we needed."

I was confused. "But that didn't give her last name," I replied.

"No, but that was enough. I accessed the FBI files, searching for a terrorist or hired killer with the first name Alexis. Bingo! Alexis Vanetti!"

"Why was her name so important?" I asked.

"It wasn't just her name I needed," he responded. "The file gave me a profile of her. I learned her background, her *modus operandi*, and what her strengths and weaknesses were."

I wrinkled my nose. "*Modus operandi?*" I echoed.

"It's Latin," he explained. "It means 'method of operation.' But the most important thing I learned was how to stop her. I picked up on a weakness, a vulnerable spot."

I was still in the dark. "I don't follow," I said.

He rolled up the newspaper. "When Chief Ramsey wouldn't listen to us, we both realized that it was up to us. I figured we needed two things— one, a way to startle the governor's motorcade into leaving quickly, and two, a way to keep the assassins from getting a clear shot at the governor before he did leave."

He smiled at me. "You and the firecrackers carried out the first objective of our mission," he chuckled.

I laughed with him. "The motorcade did leave quickly, I'll grant you that! But, it almost got me thrown in jail!"

"The second part of our mission was to keep Miss Vanetti from getting a clear shot at the governor," he went on. "That's where the mirror came in. I learned from the FBI files that she has retinal hypersensitivity. Her eyes are extremely

sensitive to light. That was why she always wore the dark glasses."

I snorted. "I just thought that they were part of a disguise to keep people from recognizing her."

He shook his head. "Anyway, that's where the mirror came in. I reflected sunlight through the window, and it was magnified by the riflescope. For her, it was like trying to shoot straight at the sun. She couldn't see a thing. She squeezed off a couple of shots, but they both went wild."

He stood up, stuck the rolled up newspaper in his back pocket, and sauntered off the porch. "Come on," he called, "let's head into town and get a Coke. My treat."

As he started to climb on his bike, I timidly laid a hand on his arm. "Jasper." He turned toward me, waiting expectantly.

"Thanks for what you said about evolution," I whispered. "I guess I needed to hear it."

He gave me a puzzled look. "Was there ever any doubt in your mind?"

I nodded miserably. "I'm afraid so," I replied. "We hear so much about it at school, and you see it at the national parks and museums, and it's in so many books, and . . .well, it just seemed so—so scientific, and . . ."

Jasper took off his glasses and polished them with his shirttail. "I never realized that you had any doubts," he said thoughtfully. "Are there still any unanswered questions?"

I shook my head as I picked my bike up by the handlebars. "Not really," I answered. "You showed me just how empty the evolutionists' arguments really are, and how flimsy their 'geological evidence' is. I guess my faith in the Bible has been restored. I just wanted to say thanks."

We pedaled down the gravel drive, and just as we reached the highway, Mayor Thompson sped by in his rusty old convertible. He waved, calling "Hey Sherlock!" as he zoomed past.

I laughed, but Jasper just shrugged and turned red. But when we reached town, it was the same thing. Everyone we passed waved at us. You would have thought we were some sort of celebrities. And, everyone called us "Penny and Sherlock."

And that was how it all began. Today, no one calls Jasper by his given name, not even his parents. He's "Sherlock" to everyone. And, I might add, the little town of Willoughby is proud to have such an effective detective as a resident—even if he is only eleven years old.

The End